The
Leonardo da Vinci
Puzzle
Codex

This is a Carlton book

This edition published in 2014
by Carlton Books Limited
20 Mortimer Street
London W1T 3JW

Editor: Matthew Lowing
Puzzle checker: Richard Cater
Art Direction: Mabel Chan
Designer: Sunita Gahir

ISBN 978-1-78097-421-7

10 9 8 7 6 5 4

Printed in China

The
Leonardo da Vinci
Puzzle Codex

Riddles, Puzzles and Conundrums
Inspired by the Renaissance Genius

By Richard Wolfrik Galland

CARLTON
BOOKS

Contents

NOVICE PUZZLES

APPRENTICE PUZZLES

EXPERT PUZZLES

MASTER PUZZLES

Introduction

Life is a puzzle, an unending series of questions
waiting to be solved. The ancient Greeks and
Romans put their minds to these everyday
conundrums and their cultures flourished, but sadly,
when the philosophy of puzzle-solving began to decline,
Europe sank into the epoch of wilful ignorance that we call
the Dark Ages.

Fortunately, after a few centuries of plagues and
superstitious poppycock, questioning minds rose from
the ashes of medieval thinking and a new era dawned:
the Renaissance.

During this period great advances were made in the
sciences, and the arts flourished as never before. The
greatest innovators of the Renaissance are still remembered
to this day, but no one exemplifies the Renaissance ideal
more than one Leonardo di ser Piero da Vinci.

Born in Florence in 1452, the illegitimate son of a peasant mother, Leonardo would become one of the greatest polymaths of all time: an artist, writer, inventor, engineer and anatomist – to name but a few of his talents. His relentless curiosity about everything combined with a formidable intellect and capacity for "lateral thinking" to make him perhaps the greatest puzzle-solver of all time. Ironically, as a man who developed an obsession with secrecy, he also left us with many unsolved puzzles of his own…

This book is a collection of brain-teasers; Some are classics that have baffled and delighted solvers for centuries. All are set in the world of Leonardo da Vinci, where we will meet some of his contemporaries and learn about a few of his greatest accomplishments. However, this is not a history book and the author has taken some flagrant liberties with events and characters to make your puzzle journey as entertaining as possible.

"The noblest pleasure is the joy of understanding."

Leonardo da Vinci

Novice Puzzles

Leonardo took on a number of pupils including Gian Giacomo Caprotti da Oreno. Better known as Salaì ("the little unclean one" or "devil"), he entered Leonardo's household at the age of 10 and turned it upside down. This did nothing to diminish Leonardo's affection for his young apprentice; it may be that the little devil's mischievous antics actually inspired some of his work. The pupil went on to produce his own paintings under the name of Andrea Salaì.

The Sum of the Arts

A work of art's value is subjective, but we shall pretend otherwise. Can you determine the value of each sketch and work out which number should replace the question mark?

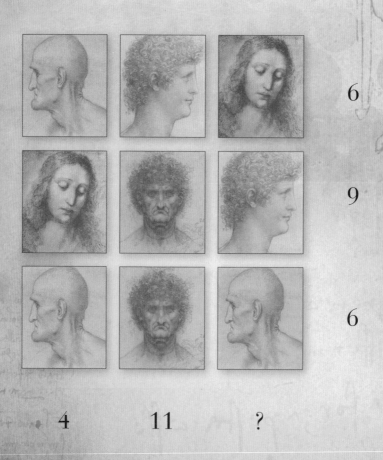

6

9

6

4 11 ?

Answer on page: 174

A Quarrel

Salaì returned home late one evening. He was unsurprised to find the Master wide awake and working on a new contraption.

"What are you making, Master?" he asked.

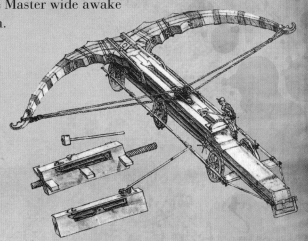

"A mechanical bow that can be rapidly reloaded," Leonardo replied. "It saddens me that its only purpose is to put a shaft of wood into a man."

Salaì giggled.

Leonardo looked up reproachfully. "Have you been drinking, young imp?"

"Schertonly not!" said the apprentice defiantly.

The Master looked dubious, but his pupil continued: "Master, I wager that I can hang up my cap, walk to the furthest wall of this room and put a quarrel from your new bow right through it. With my eyes closed!"

Despite himself Leonardo was amused by his pupil's tomfoolery. "If you can do this thing precisely as you described, I will excuse your impropriety," he said.

But, of course, he had already guessed how his pupil would accomplish this feat of marksmanship.

Have you?

Answer on page: 174

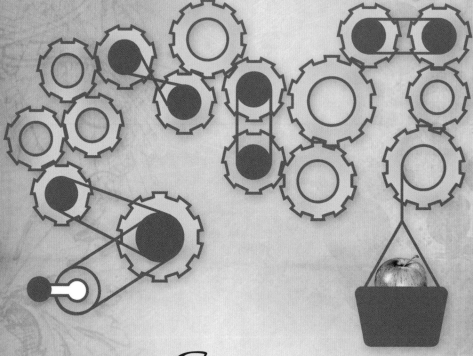

Cognition

The Master had constructed an elaborate machine to help his pupil understand some basic engineering principles.

"Your supper is on the end of this rope, young Salaì, so choose carefully if you expect a morsel of food this evening.

"Will you turn the handle clockwise or anti-clockwise to lower its load?"

Answer on page: 174

Pattern Recognition

"It is essential that you can recognize patterns if you wish to become accomplished in the arts and sciences," said Leonardo to his pupil.

"Can you tell me what sort of symbol would complete this grid?"

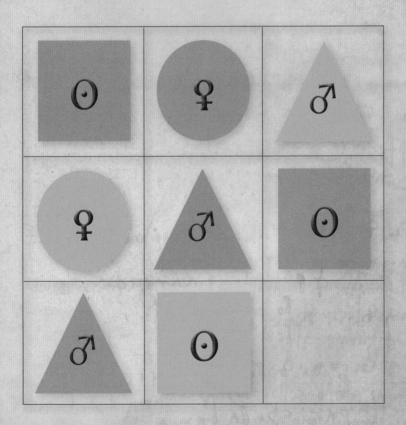

Answer on page: 174

Missing Pieces

The painting opposite is da Vinci's *Madonna of the Yarnwinder*. Five pieces of this work are missing. Can you match the numbered pieces below to the symbols on the painting?

I II III

IV V

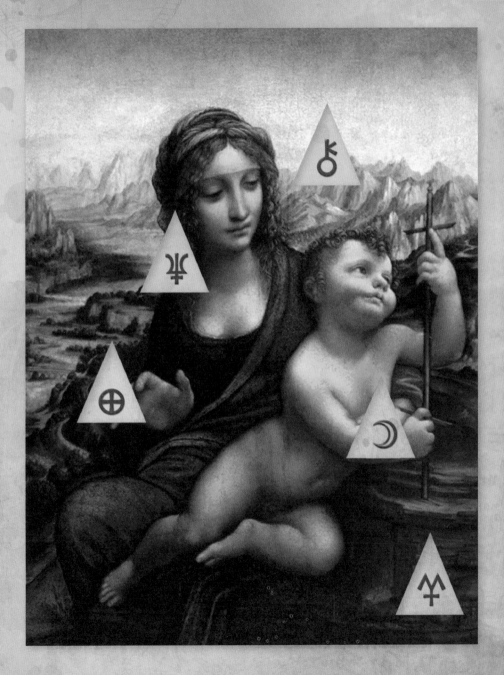

Answer on page: 175

A Dark Dream

One morning a household guard, who was given to strange, portentous visions, came before Ludovico Sforza, the Duke of Milan and recounted a terrible dream he'd had in the night:

"I saw a mighty serpent making its way gracefully through the tilled earth beside a field of lilies. Suddenly a peasant rushed from the field and decapitated the serpent with a great axe."

A gasp went up from the court. The symbols were unmistakable – the serpent was the heraldry of Milan, the Fleur-de-Lys of the hated French.

"It can only mean that the tyrant Louis is plotting against your grace," murmured Sforza's advisors.

The Duke thanked the soldier for sharing his prophecy, then ordered that he be taken out and executed.

Can you explain the Duke's harsh sentence?

You may be surprised to know that it wasn't for witchcraft or treason.

Answer on page: 176

The Merchant

A merchant came to Milan to sell his collection of precious gemstones. In the morning he sold a third of his gems, in the afternoon he sold half of his remaining stock, and in the evening, just as he was preparing to leave, a nobleman purchased his three remaining stones.

How many gemstones did the merchant bring to Milan?

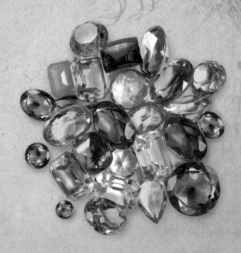

Answer on page: 176

The Turn of a Card

Four cards were laid out on Leonardo's workbench, arranged like so:

"Is it a game, Master?" asked Salaì.

"A puzzle," Leonardo explained. "The card's backs are either gold or green and their faces display either a cup or a star. So, tell me, young Salaì – which cards must you turn over to answer the question 'Does every gold card have a star on its reverse?'"

Answer on page: 176

Windows of the Soul

In the Master's studio were a number of paintings, each containing Mary, the child Jesus, the infant John the Baptist, and an angel. All of the figures in each scene were facing forward, except for the Christ Child, who had only one of his eyes visible.

If the number of paintings was equal to the number of male figures in a painting, how many eyes were there in total?

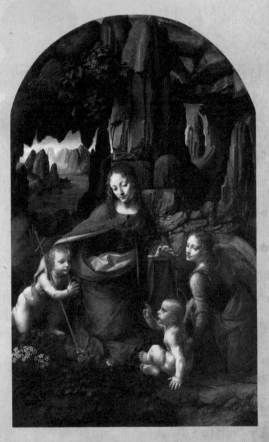

Answer on page: 177

Concentration

Look at this haphazard collection of Leonardo's sketches. Each sketch appears twice except for one. Can you see it?

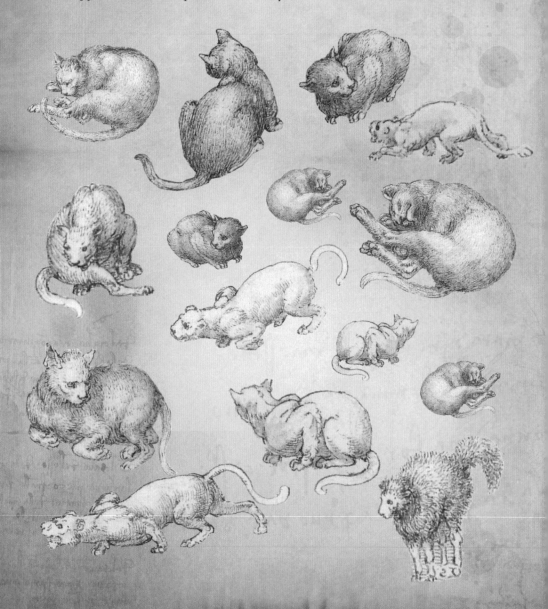

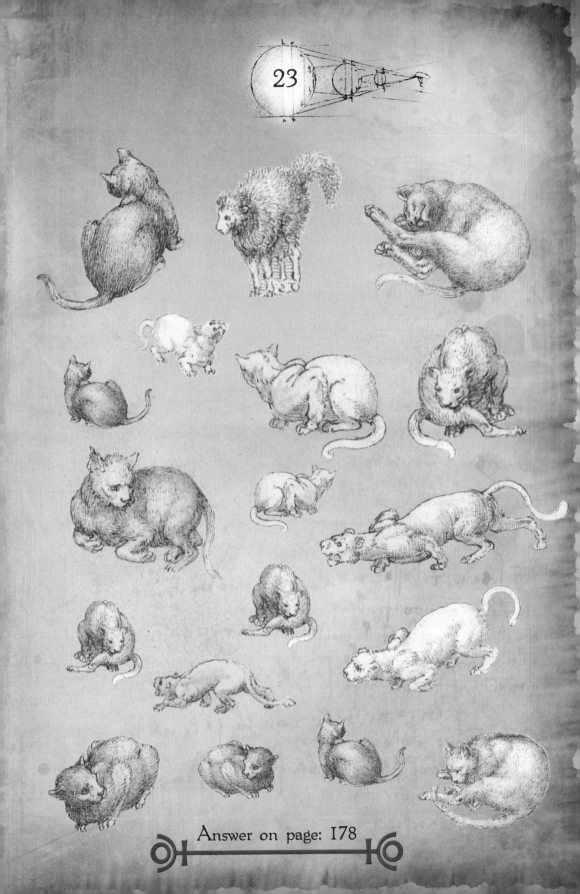

Answer on page: 178

Too Clever

Salaì broke into the Master's thoughts by thrusting a piece of inscribed parchment under his nose.

"I have a puzzle for you."

Leonardo smiled condescendingly as he regarded his pupil's offering, just rows of numerals.

```
1
1 1
2 1
1 2 1 1
1 1 1 2 2 1
3 1 2 2 1 1
1 3 1 1 2 2 2 1
1 1 1 3 2 1 3 2 1 1
```

After a while the smile became a frown. "This is nonsense, Salaì. I cannot discern any pattern in these numbers. Is this one of your pranks?"

"Not at all, Master. But did you not teach me always to look for the simplest solution?"

Leonardo rubbed his eyes and looked again. Suddenly the smile returned. "Why, you young imp!"

Can you determine what the next line should be?

Answer on page: 178

Leonardo-ku

This is a Renaissance twist on a modern favourite. Here are 9 astrological symbols.

Can you insert them into the grid below so that each line, each column and each 3x3 box contains just one of each symbol?

(puzzle grid)

Answer on page: 179

Missing Pieces

The painting opposite is the *Madonna Litta*. Five pieces of this work are missing. Can you match the numbered pieces below to the symbols on the painting?

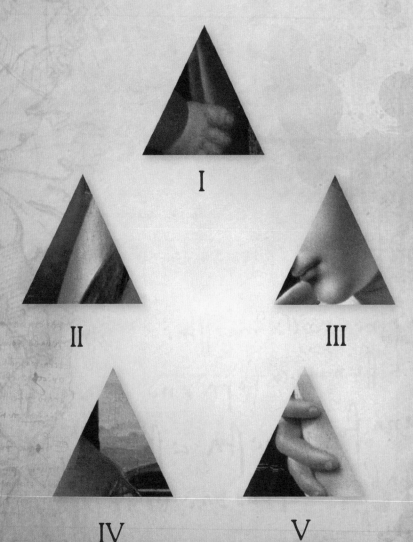

I

II III

IV V

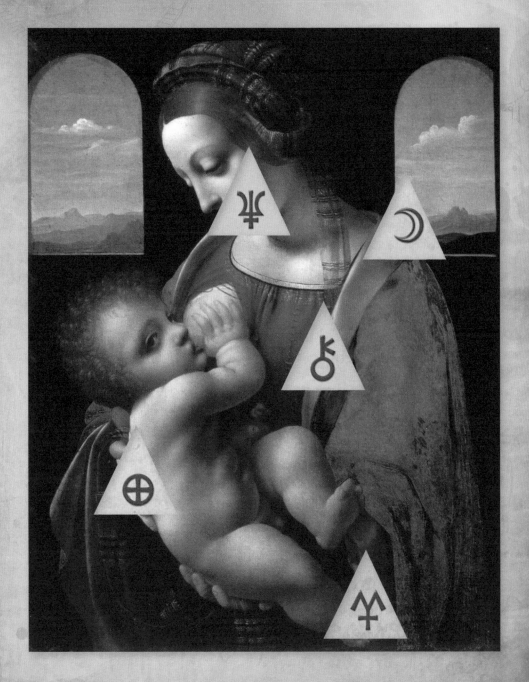

Answer on page: 180

Pattern Recognition

Look at the pattern in this matrix and determine what should be in the missing square.

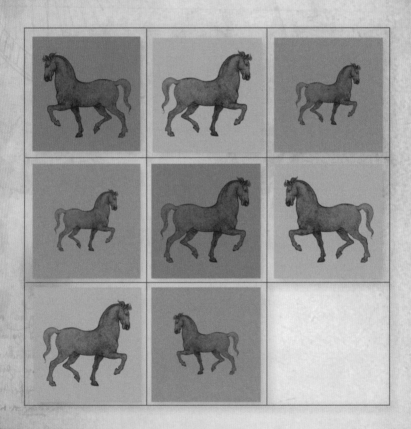

Answer on page: 181

The Art of Numeracy

"A re you feeling observant, Salaì?" asked Leonardo one morning.

"Always, Master," replied his young pupil nonchalantly.

"Take a look at this, then. As you can see, I have placed the numbers from zero to fourteen into three groups."

Group I	Group II	Group III
0 3 6	1 4 7	2 5 10
8 9	11 14	12 13

"Oh no, Master. You know how I hate arithmetical conundrums."

"Then this one will appeal to you, young imp. I wish to know into which groups I should place fifteen, sixteen and seventeen."

Answer on page: 181

Against the Grain

The Duke levied a tax on his poor serfs in the form of sacks of grain to feed his hungry soldiers.

The disgruntled peasants complied, but they made sure that all the grain that had been spoiled was included in the levy. When the tax was collected, 97 per cent of the grain was rotten.

How many bags of contaminated grain must be collected to fill one bag with edible grain?

Answer on page: 182

Leonardo-ku

Can you insert these 9 astrological symbols into the grid below so that each line, each column and each 3x3 box contains one of each symbol?

⊙ ☽ ⚷ ♄ ☿ ♓ ♃ ⚹ ♅

Answer on page: 182

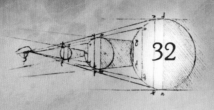

A Multitude?

"We are having guests for supper this evening," Leonardo announced.

"How many are coming?" asked Salaì.

"I can tell that all but two of them are from Milan, all but two of them are from Venice and all but two of them are from Florence."

"But, Master, our parlour is so small... wait a moment, how many is that exactly?"

Answer on page: 183

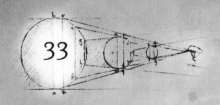

Just a Moment

"For every birth there is a death, for every genius a fool. The Creator seems to have decreed that all things strive to be in balance," mused Leonardo.

Salaì looked up absently but said nothing. The Master continued: "Observe this contraption. You can see that the lever is divided into equal units and there are two pieces of the finest thread tied on either side – but note the lack of symmetry.

"If I suspend a weight with a value of four from the left-hand thread, what weight should I suspend on the right to restore equilibrium?"

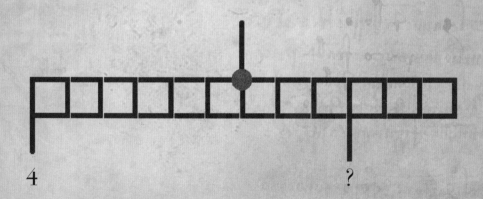

4 ?

Answer on page: 183

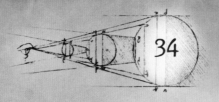

The Guilds

A perfectly square town contained the headquarters of the Alchemists Guild, the Merchants Guild, the Artists Guild and the Thieves Guild, all located in a row on the same street – as shown in the diagram below. After years of feuding, the Guild Masters decided to divide the town up equally between them. How can the town be divided so that each master controls an unbroken region that also contains their guild house?

The Sum of Arts

Determine the value of each painting and work out which number should replace the question mark.

15

8

14

11 15 ?

Answer on page: 184

One Coin

Salaì's eyes lit up when he spied the coins on the work bench.

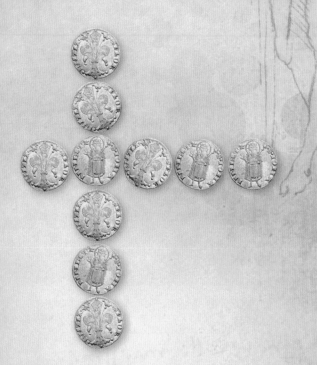

"Don't get any ideas, young imp – this is a puzzle for you to solve."

"I could solve it quite cheerfully at the market, Master," Salaì grinned.

"You can have one of these coins, if you can first move it to another position on the cross so that I can see two rows of 6 coins."

Answer on page: 184

Rope

It was a beautiful spring morning and the Master had suggested a walk. Curiously he did not pack a breakfast hamper, but instead took an enormous length of rope, which Salaì was forced to carry deep into the deep forest.

The young pupil didn't dare ask what the rope was for. Had he finally pushed the Master beyond the limits of toleration? Finally the two came out from the leafy canopy into a large circular glade surrounding a lake. In the centre of the lake was an island and on the island a single oak tree.

Leonardo stopped beside the bank of lake where a solitary willow grew. He turned to Salaì. "On that island are some rare types of mushroom. Your task today, young Salaì, is to collect them."

"Master, you know that I cannot swim."

"Indeed, that is why we brought the rope. You should know that the diameter of the lake is 400 yards and the rope you carry is a few yards longer than that distance."

With that, the Master turned on his heel and left his pupil to ponder the problem.

What should Salaì do?

Answer on page: 184

Missing Pieces

T he painting opposite is *The Virgin and Child with St Anne*. Five pieces of this work are missing. Can you match the numbered pieces below to the symbols on the painting?

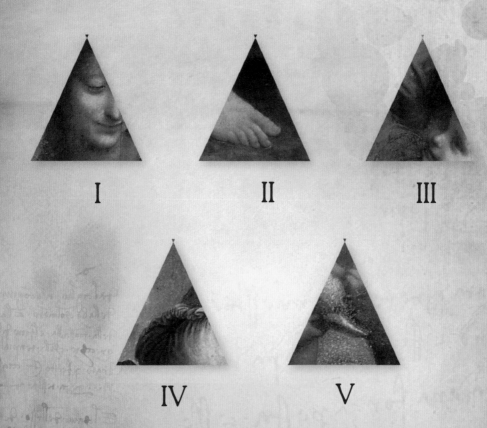

I

II

III

IV

V

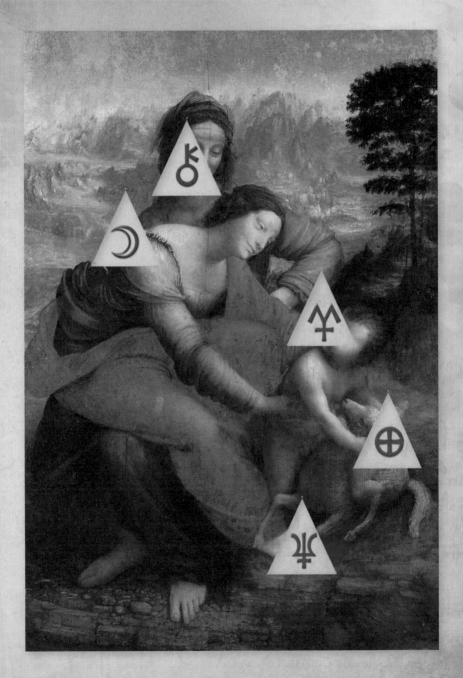

Answer on page: 185

Leonardo-ku

Here are 9 astrological symbols.

⊙ �619 ♉ ♃ ☿ ✹ ⚳ ♅ ☿

Can you insert them into the grid below so that each line, each column and each 3x3 box contains one of each symbol?

Answer on page: 186

The Sands of Time

Mechanical clocks were in use during the Renaissance but wouldn't become truly accurate until the invention of the pendulum, some 200 years after the death of Leonardo.

Unsurprisingly there are plans for an improved time-keeping device in his notes.

A less sophisticated method of measuring minutes was the hourglass. These could be filled with enough sand to measure a specific period. Suppose you have a 4-minute glass and a 7-minute glass but you wish to measure 9 minutes. How would you do it?

Answer on page: 187

Pattern Recognition

Look at the pattern in this matrix and determine what should be in the missing square.

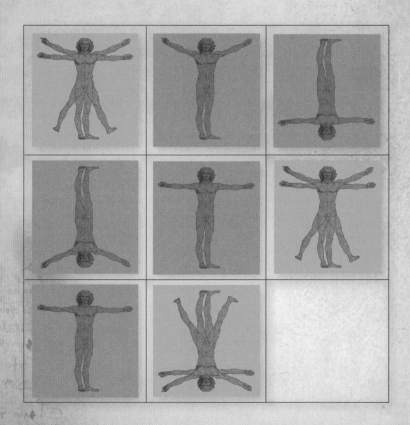

Answer on page: 187

Just a Moment

"You should now be adept at bringing balance to the Universe, young Salaì. What weight should be attached to the empty thread to make all as it should be?"

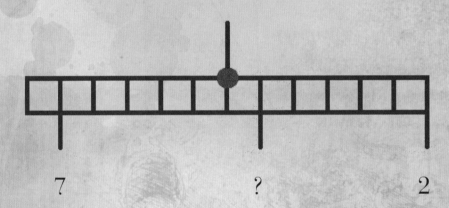

7 ? 2

Concentration

L ook at this haphazard collection of Leonardo's sketches. Each sketch appears twice except for one. Can you see it? Watch out – some images are flipped or different sizes, but they're still the same sketch.

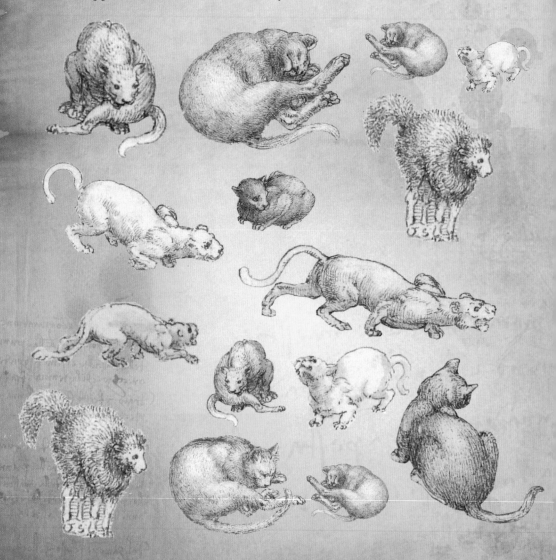

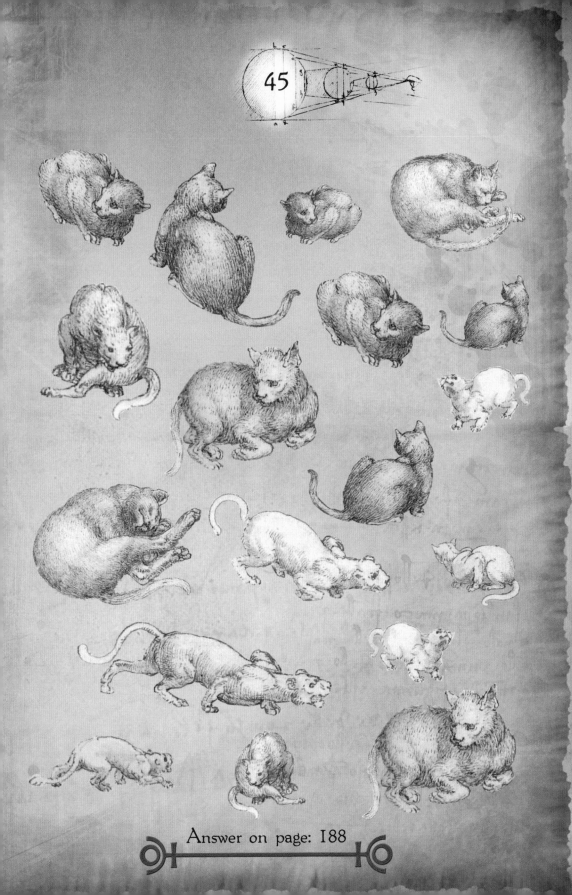

45

Answer on page: 188

The Sum of Arts

Determine the value of each painting and work out which number should replace the question mark.

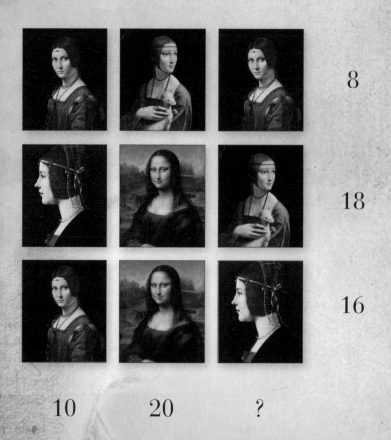

8

18

16

10 20 ?

Answer on page: 188

Two Coins

When Salaì returned from the market, he found the remaining coins arranged in a square.

He noticed that they were alternatively arranged heads and tails.

"We can have supper if you can rearrange this square so that each vertical column is made of coins all facing the same way, either heads or tails."

"That's easily done."

"You are permitted to touch only two coins."

Salaì mumbled a curse.

Answer on page: 189

Missing Pieces

The painting opposite is the *Madonna with the Carnation*. Five pieces
of this work are missing. Can you match the numbered pieces below to
the symbols on the painting?

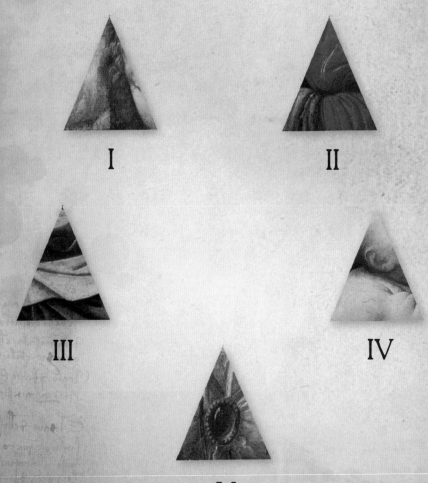

I

II

III

IV

V

49

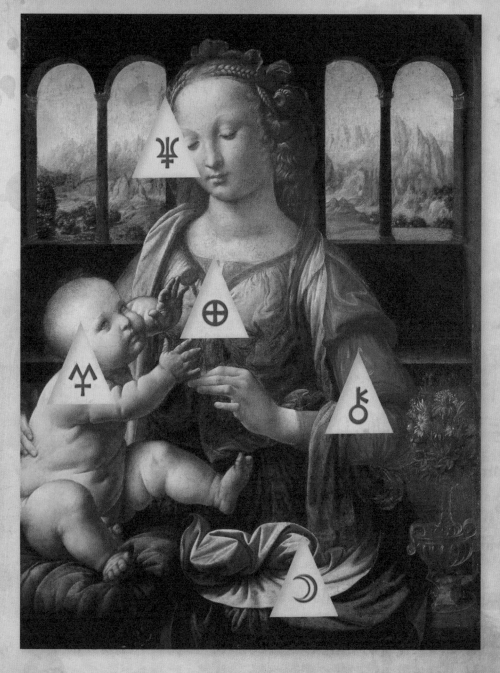

Answer on page: 190

Three Fees

The Duke had commissioned an architect, a sculptor and a painter to build and furnish his new chapel.

He paid a total deposit of 15 florins to the three men. If he had paid the sculptor twice as much as he really had, then the combined fee of the sculptor and painter would be the same as the architect's fee.

How much did the Duke pay each man?

Answer on page: 191

Box Clever

"When painting from life, put onto the canvas everything you see. But you must endeavour to comprehend the elements that you cannot see. That is the secret to depth and realism."

Salaì's eyes were starting to glaze over, so the Master decided to take a different tack. He produced four paper boxes and positioned them so that only three sides of each were visible.

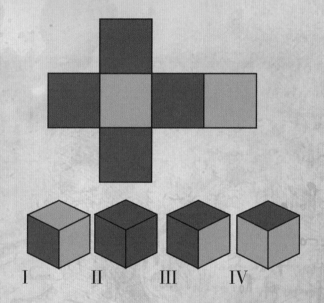

I II III IV

"Do you wish me to paint them, Master?" asked Salai, barely restraining a yawn.

"No. I want you to tell me which of them was constructed using this cruciform plan."

Answer on page: 191

"There are three classes of people: those who see, those who see when they are shown, those who do."

Leonardo da Vinci

Apprentice Puzzles

Leonardo began his own apprenticeship at the age of fourteen in the workshop of the renowned Florentine painter Andrea del Verrochio.

In 1475 Verrochio painted the *Baptism of Christ* and was assisted by the young Leonardo, who painted an angel in the bottom left of the picture.

It is said that Verrochio was more than impressed by Leonardo's contribution. Declaring that he had been surpassed by his pupil, he resolved never to pick up a paintbrush again!

Casualties

Two allied generals marched to war against a common enemy. During the battle the soldiers were evenly matched by their opponents in terms of numbers and quality of troops.

"I can't understand it," says the second general. "Your men are the equal of mine in every way – yet your army has sustained twice as many casualties."

What could explain this disparity?

Answer on page: 192

Riders

"There were horses and men fleeing from Florence. Forty-four legs and thirty eyes, to every steed a rider!" shrieked the old man.

"Does he ever say anything that makes sense?" asked Salaì.

"He always makes perfect sense in his own way," said Leonardo, evidently lost in thought. "We had better inform the Duke; it sounds like the horsemen took a prisoner with them."

How did Leonardo reach this conclusion?

Answer on page: 192

Number Magic

Fill the empty squares of this grid with the missing consecutive numerals between I and IX so that each row, column and long diagonal adds up to the same total.

Answer on page: 193

Vulgar Factions

"The court has split into two opposing factions," said Leonardo. "If one more lord defects to Rome, there will be twice as many Papal loyalists as there are friends of the Medicis. However, if one of the Pope's supporters joins the Medicis, the numbers will be equal."

Salaì frowned. "So how many supporters does each faction have at the moment?"

"I just told you." said Leonardo.

What is the answer?

Answer on page: 193

Missing Pieces

The painting opposite is *Saint Jerome in the Wilderness*. Five pieces of this work are missing. Can you match the numbered pieces below to the symbols on the painting?

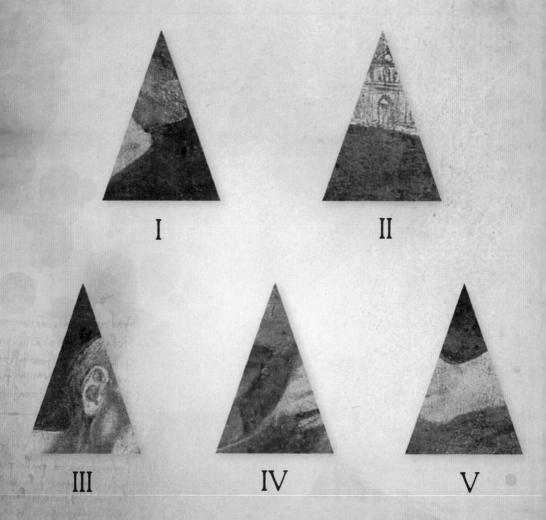

I

II

III

IV

V

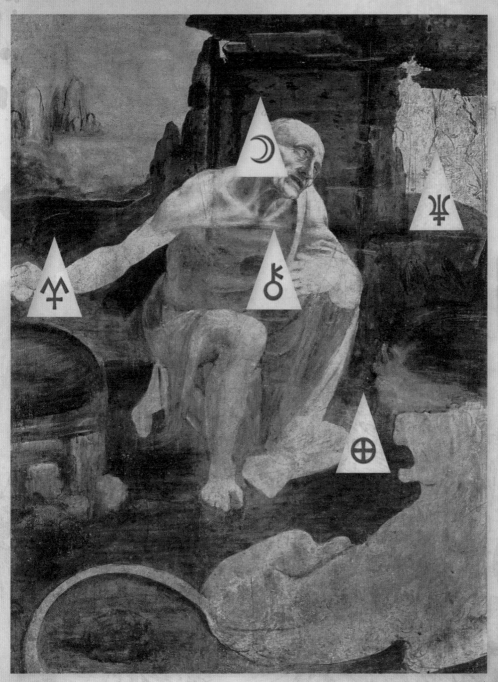

Answer on page: 194

A Sign

Leonardo and Salaì had left Florence and were heading towards Volterra when they came upon a signpost that had been uprooted.

"The people of these parts are not friendly to the Medicis," remarked Leonardo. "They often destroy signposts to confound visitors. Fortunately, this one is only knocked down."

"But how can we find our way, Master?" The sign is useless lying in the mud.

Answer on page: 195

Leonardo-ku

Can you insert these 9 astrological symbols into the grid below so that each line, each column and each 3x3 box contains one of each symbol?

Work for Idle Hands

Leonardo was commissioned to paint a frieze by a pious, very mean but otherwise stupid patron.

"I shall have the work completed in 36 days," said Leonardo.

"And your payment?" grumbled the patron.

"Oh, have no fear. On the first day you may pay me but a single coin."

The patron looked astonished.

"If you are perfectly satisfied that I have made a good start, you can pay me two coins on the second day and three coins on the third… and so on."

"We are agreed," said the patron, whose forehead had creased from the simple arithmetic.

How much is Leonardo's total fee?

Answer on page: 196

Diminishing Returns

A soldier arrived at the Duke's palace, blood-spattered and exhausted.

After being given a mug of ale, he was able to recount his sorry tale:

"We lost half our men in the battle with the French, then on the march home we lost 20 per cent of our strength in skirmishes with outlaws. Of the remainder, a quarter succumbed to their wounds as we made our way back across friendly country. When we arrived here, the remaining 29 men headed straight for the tavern, but I thought I should report to your grace straight away."

How many soldiers were there at the start?

Answer on page: 196

When Exactly?

"**M**aster, today is the sixth of the month."

"Well observed, young Salaì. Remind me, how is that significant?"

"You promised to reveal the secrets of alchemy this month, Master!"

"And I shall teach them to you, on the day before three days from the day after tomorrow."

"And I shall hold you to that, Master... when is that exactly?"

Answer on page: 196

Vulgar Fractions

"The Medicis are bankers first and value accountancy more than they value art." grumbled Leonardo after a rather fruitless meeting with his patron.

Salaì remained silent.

"And how are your faculties, young imp?" snarled the Master. "Tell me, what is one-half of two-thirds of three-quarters of four-fifths of five-sixths of six-sevenths of seven-eighths of eight-ninths of nine-tenths of one hundred?"

Answer on page: 197

Attraction

"You recall our discussion on the mysteries of magnetism, young Salaì?"

"Yes, Master. I'm still trying to get the iron filings out of my breeches."

"Observe, here I have two bars of iron that look completely identical. However, one of them is magnetized and the other is not."

Salaì took a step back.

"Calm yourself, boy. All I wish to know is: can you determine which of the bars is magnetized by shifting them on the workbench – without lifting them or employing any other object?"

Answer on page: 197

Numerals

It had become a matter of routine that, upon waking, Salaì would go to the work bench and find a puzzle that the Master had constructed the night before. This morning was no exception.

A set of wooden sticks which, on closer inspection, turned out to be an equation written in roman numerals:

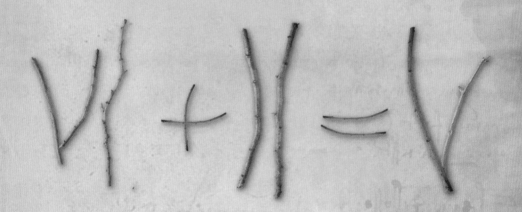

"Ha! Your arithmetic is faulty, Master." Salaì remarked.

"Indeed," replied Leonardo without looking up from his notes. "Perhaps you could correct it for me? However..."

"Let me guess – I can move only one of the sticks?"

Leonardo smiled, "Precisely."

Answer on page: 197

Missing Pieces

The painting opposite is the *Benois Madonna*. Five pieces of this work are missing. Can you match the numbered pieces below to the symbols on the painting?

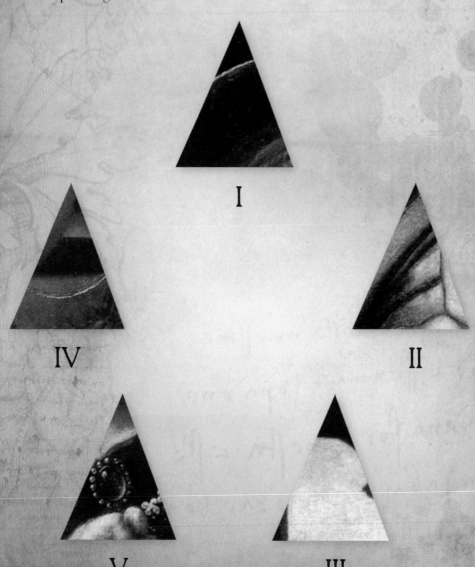

I

IV

II

V

III

69

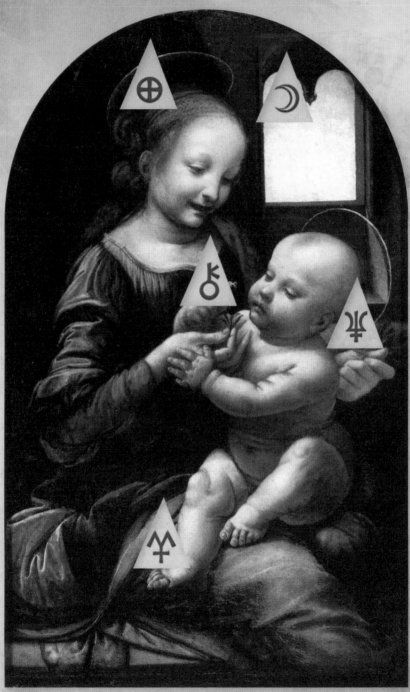

Answer on page: 198

In Vino Veritas

"Tell me, Salaì, is our last barrel of wine over half-full or more than half-empty?"

Salaì looked at the darkly reflective surface of the wine in the barrel. It might have been half full, or half empty. "Is this a test of my optimism, Master?"

"No, it's a perfectly concrete question. Surely you can tell me without using measuring implements or asking stupid questions?"

Answer on page: 199

Cannon

Leonardo was testing the rate of fire of two siege cannons. The first could fire 5 shots in 5 minutes, the second 10 shots 10 minutes.

Which cannon could fire a dozen times more quickly?

Answer on page: 199

Wheels in Motion

"A nother model to exercise your mind, young Salaì," said Leonardo.

On his workbench Leonardo had 3 wooden rollers, on which he placed a tile of slate.

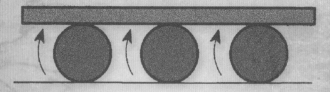

"If the rollers have a circumference of 1 braccio, how far forward will the tile have moved after the rollers have made one complete revolution?"

Answer on page: 199

Leonardo-ku

Can you insert these 9 astrological symbols into the grid below so that each line, each column and each 3x3 box contains one of each symbol?

⊙ ☽ ♓ ♄ ♅ ☾ ♑ ⚹ ♆

Answer on page: 200

Accuracy

"Rate of fire is important, but is no substitute for accuracy. Today we will test-fire our new cannon at some targets."

Leonardo and Salaì had hauled the siege guns into a large field on the outskirts of Florence, where the Master had erected some realistic fortifications fashioned from wood and stucco.

On the first test-firing, both fired 50 shots and hit their targets 25 times. After recalibrating for a target at longer range, the first cannon fired 34 shots and scored 3 hits; the second cannon fired 25 times and did not hit once.

"The first cannon is superior, Master," said Salaì confidently.

"Perhaps," said Leonardo. "Although, had this been a shooting competition, I wouldn't be so sure."

Why?

Answer on page: 200

Recruitment

Three young men had applied to join the Duke's guard.

Two were skilled in swordsmanship, two were trained with a crossbow and two were competent horseback riders. The man who had no skill with a sword had no expertise with a crossbow either, and the one who had no crossbowmanship skill couldn't ride.

What expertise did each applicant have?

Answer on page: 201

Defection

Two enemy generals had the same number of soldiers. How many men would have to defect from the first general's army (to join the enemy's ranks) so that the second general had 1000 soldiers more than the first?

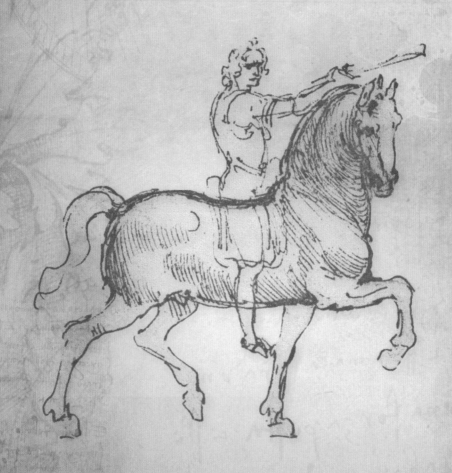

Answer on page: 201

Deadline

C esare Borgia's cruel sense of humour was infamous.

"Da Vinci, your failure to complete my sculpture will not be tolerated. Choose your punishment."

"My Lord?"

"You can either lose a hand or an eye, or I'll have my men throw you into a pit of wild dogs who have not eaten in five months."

Which fate should our imperilled artist-sculptor-inventor choose?

Answer on page: 201

Missing Pieces

The painting opposite is the *Virgin of the Rocks*. Five pieces of this work are missing. Can you match the numbered pieces below to the symbols on the painting?

I

II

III

IV

V

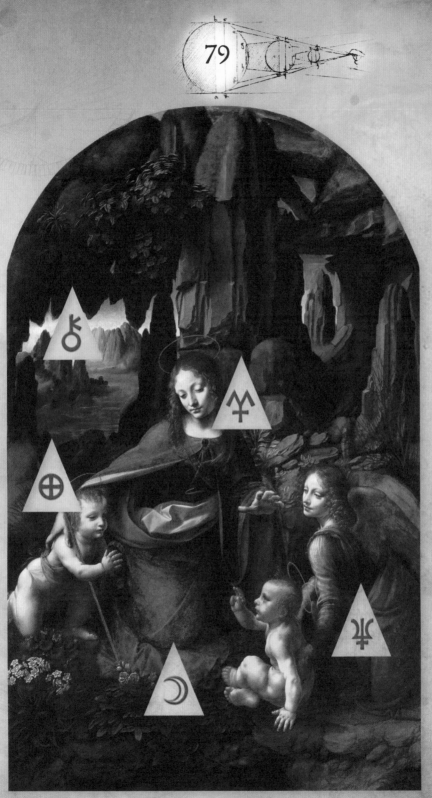

Answer on page: 202

Generosity

"Did you attend mass this morning, Salaì?" asked Leonardo.

"Yes, Master. We were reminded of the virtue of generosity."

The Master smiled, "There is one thing that can be kept or shared, but once shared will cease to be."

What is it?

Answer on page: 203

Papal Bull

Rodrigo Lanzol Borgia made a good many enemies during his lifetime. His family were accused of all manner of unholy crimes, from incest and adultery to theft and murder.

However, even though he lived in Rome during the reign of Pope Alexander VI, Borgia was never excommunicated.

Can you say why?

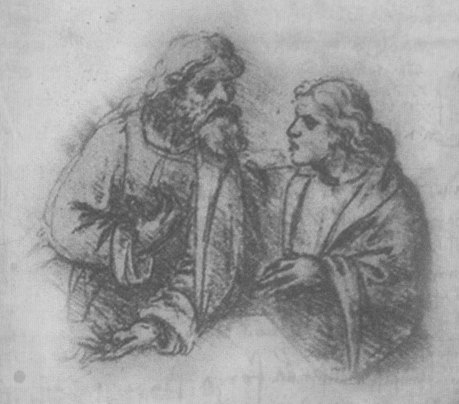

Answer on page: 203

Horse Race

Giovanni Borgia considered himself to be an accomplished rider and challenged three companions to a horse race. He overtook the rider who was in second place but on the final stretch was overtaken by two other riders.

In what place did he finish?

Answer on page: 203

Leonardo-ku

Can you insert these 9 astrological symbols into the grid below so that each line, each column and each 3x3 box contains one of each symbol?

Answer on page: 204

The First Shall Come Last

Rodrigo Borgia set a challenge for his competitive sons Giovanni and Cesare.

"I propose a horse race around the palace," said the father, "but with a difference. Matthew 20:16."

"The last shall be first, and the first last?" asked Giovanni.

"Just so," said Rodrigo. "The one whose horse comes last shall earn my favour."

Giovanni and Cesare paused for a moment, then raced off to the stables.

They emerged seconds later, both mounted and racing at full gallop.

Why were both brothers so eager to finish first?

Answer on page: 205

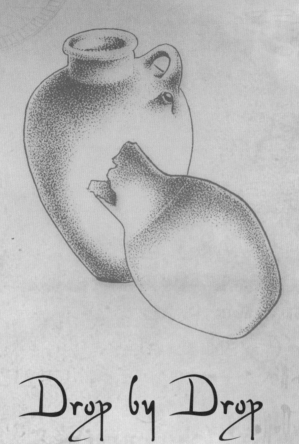

Drop by Drop

Leonardo took a clay vessel and carefully measured wine into it, drop by drop. His apprentice watched in silence until at last the Master spoke.

"Tell me, Salaì, how many drops of wine can be put into an empty goblet?"

Answer on page: 205

The Power of Three

S alaì found a strange pentagram inscribed on a roll of parchment.

"Is this some kind of sorcery, Master?" he asked in a whisper.
Leonardo laughed.

"Not magic, young imp, but mathematics. How many triangles do
you see?"

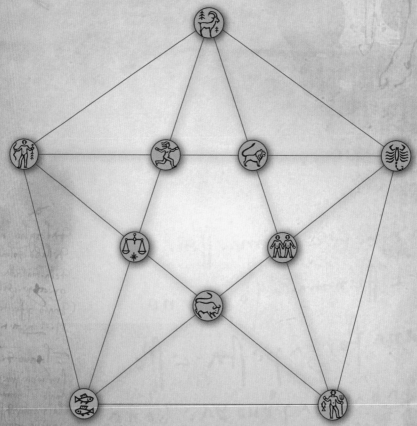

Answer on page: 205

The Sum of Arts

Determine the value of each painting and work out which number should replace the question mark.

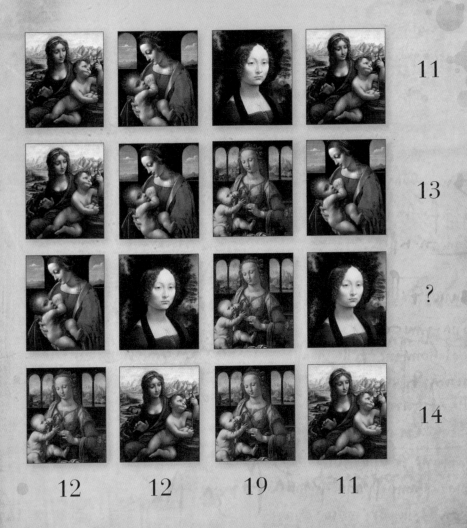

11

13

?

12 12 19 11

14

Answer on page: 206

Missing pieces

The painting below is the *Annunciation*. Five pieces of this work are missing. Can you match the numbered pieces to the symbols on the painting?

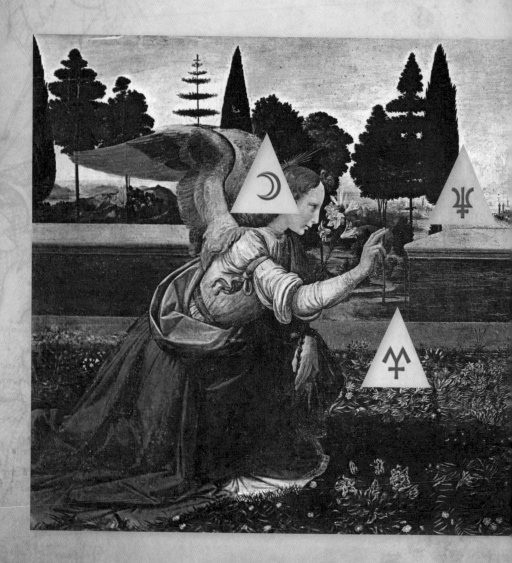

89

I II III IV V

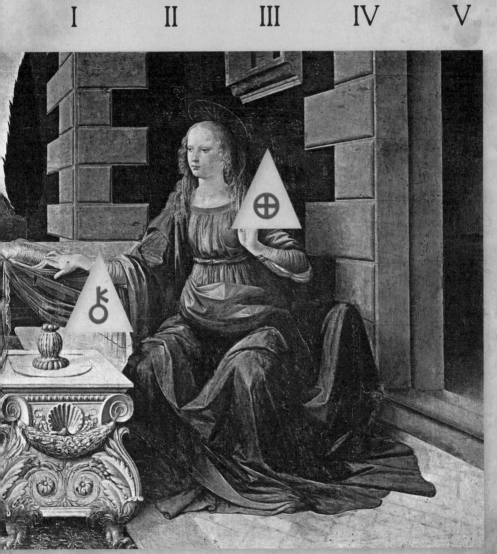

Answer on page: 206

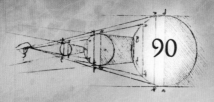

Cognition

Salaì was alarmed to see that the wall of the workshop was once again festooned with cogs and wheels. An explanatory note from the Master read:

Happy birthday, young imp. Your present is on the end of the chain. Make sure you turn the handle properly, or the device will jam.

Which way should Salaì turn the handle to make his present descend?

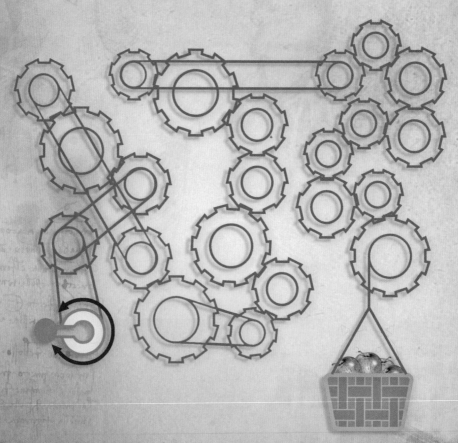

Pattern Recognition

Look at the pattern in this matrix and determine what should be in the missing square.

"Iron rusts from disuse; water loses its purity from stagnation... even so does inaction sap the vigour of the mind."

Leonardo da Vinci

Expert Puzzles

Leonardo's life was varied and exciting. His multitudinous talents took him all over Italy.

In 1482 he created a lyre (a stringed instrument) from silver in the shape of a horse's head. His patron Lorenzo de Medici sent Leonardo to present the instrument to Ludovico Sforza, the Duke of Milan, as a peace offering.

It was in Milan that he painted *The Last Supper*.

Witchcraft

During one of the hardest winters in memory, Leonardo and Salaì found themselves in a particularly hostile village, whose inhabitants took exception to the Master's unorthodox views.

The two were forced to spend the night in a tavern while the village was battered by a blizzard. After a few flagons of very poor ale, they were caught off-guard and set upon by villagers. They tied up Leonardo but freed the boy after the landlord's daughter convinced them that he was an unwitting victim who had been beguiled by the devil Da Vinci.

"When the morning bell rings, we shall burn the heretic!" announced the Village Elder.

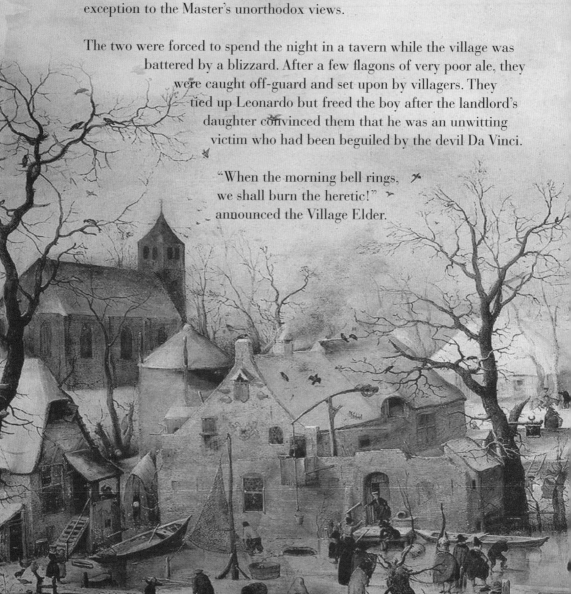

"That's very kind of you," said Leonardo defiantly, "I'm surprised you can spare the firewood."

The next morning was bright and sunny, and the entire village had come out to witness the execution. Leonardo was bound to a large pyre and a group of zealous villagers waited in a circle with torches.

A sudden shriek filled the air. It was Salaì.

"An angel came to me," he exclaimed, "and told me that the morning bell would not ring while you hold a blameless man!"

"What utter nonsense!" said the Elder. But, sure enough, the bell would not ring and the execution had to be postponed.

The bell tower's ladder had apparently been damaged in the night, so it was mid-afternoon before the villagers were able to check if the bell had been tampered with.

To their astonishment, they found it to be in working order. Leonardo and Salaì were released and sent on their way by the awe-struck villagers.

"You're welcome," said Salaì with a grin.

How had he rescued Leonardo?

Answer on page: 209

Mistrust

Three Borgias and three Medicis found themselves on an island with just one small two-man rowboat to give them passage across the water.

The Borgia reputation for treachery prompted the Medicis to insist that the Borgias must never outnumber them on either bank.

How can they all get off the island?

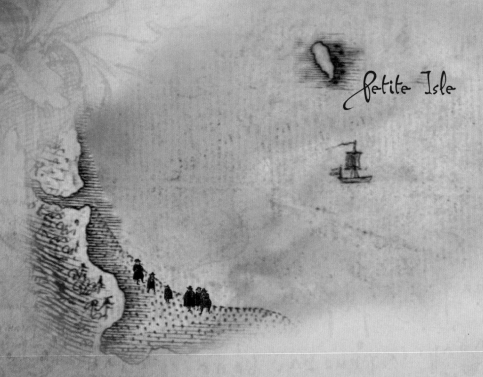

Petite Isle

Answer on page: 209

The Truth Will Set You Free?

Leonardo had been charged with heresy and imprisoned by an overzealous cardinal.

With his ingenuity, it was child's play to escape from his cell and convince the guards that he was an agent of the Vatican.

Unfortunately, the guards were under special orders from the cardinal: one must only tell the truth and one must only lie. Only the cardinal knows which one is which.

This would not have been such a calamity were it not for the fact that each guarded a locked door, one of which led to a series of tunnels and, ultimately, freedom; the other to an inescapable death-trap.

Leonardo could ask only one question, or he risked alerting the guards to his true identity.

What question should he ask?

Answer on page: 209

Leonardo-ku

Can you insert these 9 astrological symbols into the grid below so that each line, each column and each 3x3 box contains one of each symbol?

☉ ☽ ♓ ♄ ♅ ☾ ♃ ♆ ♀

♀			♅			♓		♃
	♓						♆	
	♅	♃						♀
	♀			♅				
	♆	♓		♃				
			☉					☽
			♃			♓	♅	
☉						♆		
♄	♃							☉

Answer on page: 210

Hats

Leonardo was interviewing four potential apprentices: Alberto, Benito, Caspar and Donatello. He had them all sit with their eyes closed while he placed a hat on each of their heads.

"There are two black hats and two white hats," he told them. He then placed the boys so that Benito and Donatello couldn't see the others at all.

Alberto could see only Benito, while Caspar could see only Alberto and Benito.

"The first one who can tell me what colour hat he's wearing will be my apprentice. Now, open your eyes." After an awkward silence, one boy finally spoke and answered correctly.

Who got the apprenticeship?

Answer on page: 210

More Hats

W ord soon spread about Leonardo's use of hats to select candidates. A local merchant was looking to take on an apprentice from three candidates and asked Leonardo's help.

"This is Estefan, Ferdinand and Gabriel. They are all bright boys, but sadly I can employ only one."

Leonardo invited them all to his studio and announced. "I have five hats, three black and two white."

He signalled for the three boys to sit and close their eyes, then placed a hat on each of their heads before locking the remaining two hats in a chest.

"You can open your eyes now. Who can tell me what colour hat they are wearing?"

Estefan opened his eyes and looked around before admitting, "I have no idea."

Ferdinand did exactly the same.

Gabriel did not open his eyes but grinned happily and said, "My hat is black!"

How did he know?

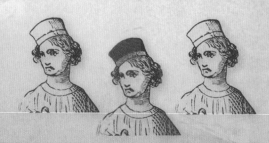

Answer on page: 211

Lead into Gold

Leonardo's client had commissioned the Master with a down payment of 9 coins.

The client was a notorious swindler who was known to always slip a fake coin into his payments.

These fake coins were just slightly heavier than the legal tender.

"May I just check the coins?" asked Leonardo

"Make it fast, da Vinci, I haven't got all day," said the client shiftily.

Leonardo produced a pair of scales. "I just need to take two measurements," he said.

What did Leonardo do next?

Answer on page: 212

Missing Pieces

The painting below is the *The Last Supper*. Five pieces of this work are missing. Can you match the numbered pieces to the symbols on the painting?

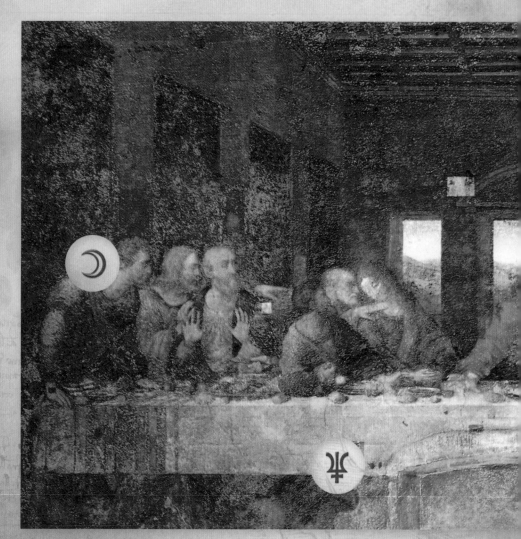

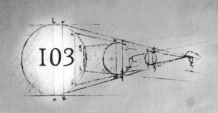

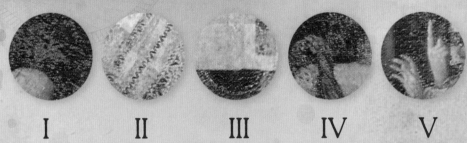

I II III IV V

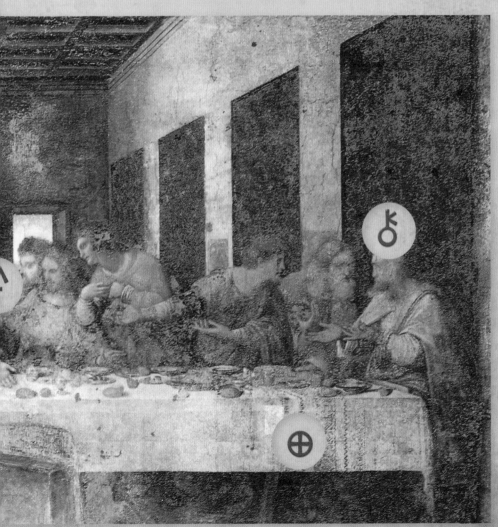

Answer on page: 212

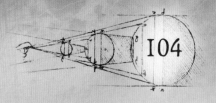

Something from Nothing

"Your war machines are all very well, da Vinci, but Florence needs men," said Medici.

"Maybe deception will prevail where numbers fail," mused Leonardo.

"What do you mean?"

"I can turn two lines of five soldiers into five lines of four soldiers."

"Are you saying that you can conjure more men from thin air?"

"Sadly not, but a truthful, if deceptive, leak of our strength might give your enemies pause for thought."

How would Leonardo do this?

Answer on page: 213

The Last Straw

The two Borgia sons were once again squabbling for their father's favour. Rodrigo placed eleven straws before them.

"One for each of the loyal disciples," he said pointedly.

"In turn, you must take one, two or three of the straws. The one who takes the last straw will *not* receive my favour."

He signalled for Cesare to take the first turn.

How many straws should he take?

Answer on page: 213

Checkers

A trip to the tavern with Leonardo was often entertaining – and profitable.

Before he had quaffed his first ale of the evening, Leonardo was already surrounded by intrigued onlookers, ready to make a wager.

"I have here four white checkers and four black checkers. Can anyone put them in a line of alternating colours using just four moves and two fingers?"

I II III IV V VI VII VIII

Answer on page: 214

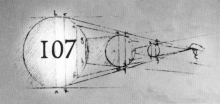

Leonardo-ku

Can you insert these 9 astrological symbols into the grid below so that each line, each column and each 3x3 box contains one of each symbol?

Answer on page: 215

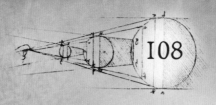
flagons

Later in the tavern Leonardo arranged six flagons in a line, three full flagons followed by three empty flagons.

"I wager that I can rearrange this line so that they alternate, empty and then full – by touching only a single flagon."

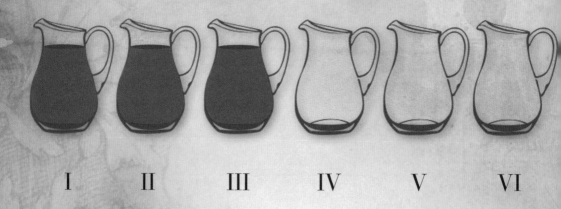

I II III IV V VI

There was a commotion among the inebriated clientele as men jostled to place a bet on Leonardo's table. Salaì was assiduous in keeping track of the coin.

"By God, Florentines are easy to dupe," he hiccupped.

Answer on page: 216

The Herald

Two armies that are 120 furlongs apart begin marching towards one another at a rate of 10 furlongs an hour.

As soon as they begin their march, a herald rides out from one army to meet the other, then returns, travelling continually back and forth between the two approaching battle lines at a speed of 80 furlongs per hour.

How far has the herald travelled when the two armies clash?

Answer on page: 217

Battles

A lord went on campaign with his army. After each battle he took a tally of the dead and found he had lost ten more than half the number of soldiers he had at the start of the battle.

This was the same for all five battles of the campaign. By the end of the campaign, he had lost all his men.

How many men did he take to war at the start of the campaign?

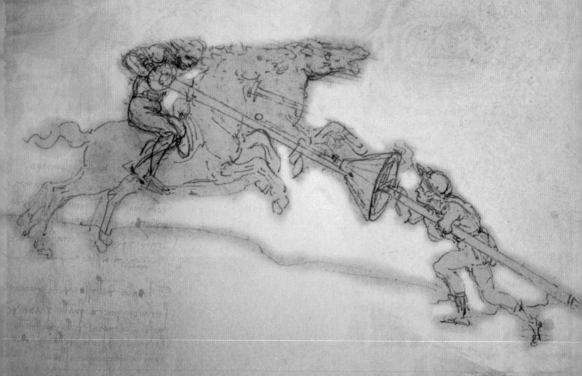

Answer on page: 217

Land Grab

Four cardinals were squabbling over an area of land. They approached the Pope for arbitration.

Each cardinal demanded that his region be the same size and shape as the other three.

How should the Pope divide the land?

The Treasure Trove

Leonardo's most secret discoveries were hidden in a chest behind a curious double-sided portrait, consisting of 16 tiles in an ingenious mechanism.

When a lever is pulled, all the tiles of its column or row are flipped over to reveal the sections of the other portrait.

The levers are labelled with letters as shown. If the wrong combination of levers are pulled, a gunpowder charge is detonated – destroying the secrets and possibly the seeker too.

What do you think the most likely combination is?

R

A

O

L

Answer on page: 219

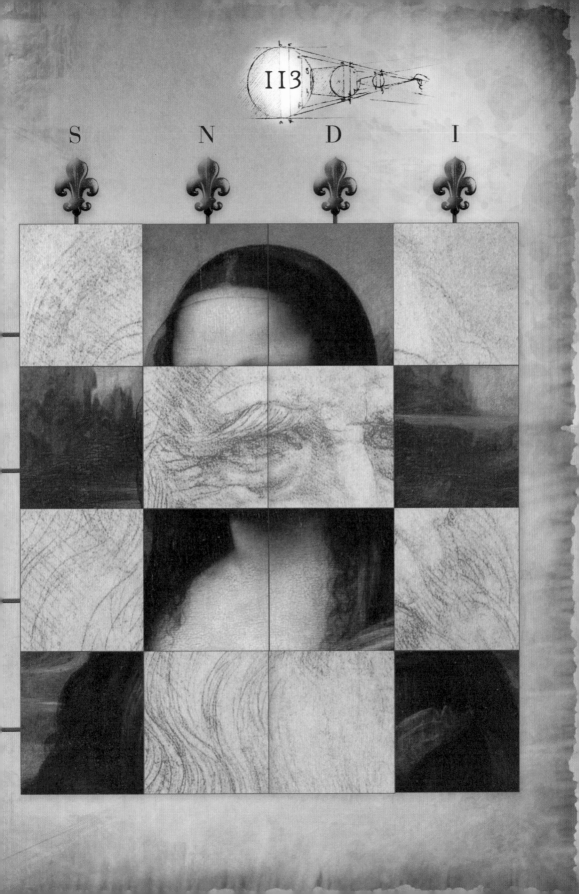

S N D I

Heresy

"Almighty God has decreed that your sins will find you out. Numbers 32:23," the Inquisitor intoned menacingly.

Leonardo said nothing. The Inquisitor held out a bag of black cloth. "And the angel swung his sickle into the earth and harvested the vine of the earth, and threw the grapes into the great winepress of the wrath of God. Revelation 14:19.

"In this sack are two grapes, one white and one black. If you draw the white grape, the Lord has judged you innocent. If you draw the black one, you shall burn for a heretic."

Leonardo reached inside the bag. The malevolent gleam in the Inquisitor's eye confirmed his suspicion that both of the grapes were black.

But one did not accuse an Inquisitor of lying.

He put his hand inside the bag and muttered, "Matthew 15:11."

How can Leonardo avoid going to the pyre?

Answer on page: 220

Spies

Cesare Borgia had dispatched three spies to determine how many French sympathizers were living in the surrounding area.

"There are 50 or more," said the first spy.

"I beg to differ, my lord. There are less than 50," said the second spy.

The third spy shook his head. "There is at least one."

If only one of the spies is telling the truth, how many French sympathizers does Borgia have to contend with?

Answer on page: 220

Missing pieces

T he painting opposite needs no introduction. Six pieces of this work are missing. Can you match the numbered pieces below to the symbols on the painting?

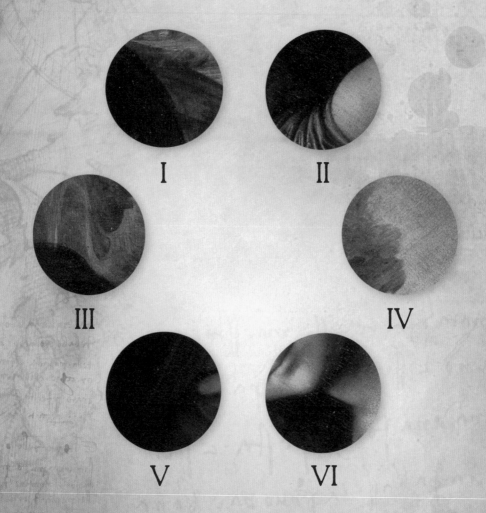

I

II

III

IV

V

VI

Answer on page: 221

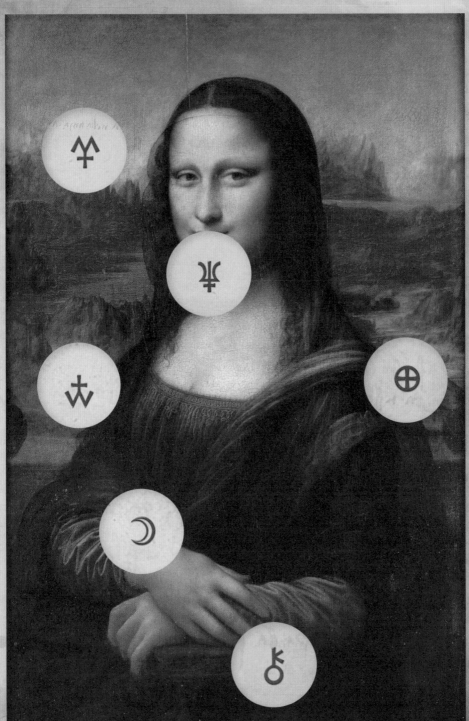

Self-fulfilling Prophecy

Can you fill in the blanks using single digit numbers?

The number 1 occurs … times

The number 2 occurs … times

The number 3 occurs … times

The number 4 occurs … times

The number 5 occurs … times

3

1 2 3

1 2 3 4 5

Answer on page: 222

1000 Days of Sin

A monk arrived in a town preaching a new heresy.

On the first day, no one came to hear him.

On the second day, one person came to hear his sermon and fell under the preacher's spell. On the second day, two more joined the congregation. On the third day two more joined the congregation, on the fourth day three more and so on...

After 1000 days, how many heretics were there in the town?

You may find that some problems are best tackled from both ends at once.

Answer on page: 222

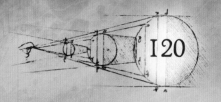

Leonardo-ku

Can you insert these 9 astrological symbols into the grid below so that each line, each column and each 3x3 box contains one of each symbol?

☉ ☽ ♓ ♄ ☿ ♓ ♃ ⚸ ♅

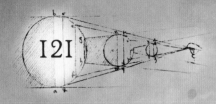

Money-go-round

Take two coins of equal size and put them side by side so that they touch. Hold one in place and roll the second around the circumference of the first without letting it slip.

How many revolutions do you suppose the second coin will have made when it returns to its starting position?

Guardroom

Two feuding lords lived in neighbouring realms whose capitals (Sinistra and Destra) were separated by a river. The only way across the river was by a single bridge but, after the latest round of hostilities, it had been agreed by both sides that no one should use it to travel between the realms.

In the centre of the bridge was a tower, where a single guard was given the duty of enforcing the partition. The guard was under instruction to come out of his tower every 6 minutes, and send anyone on the bridge back to their realm or else use his crossbow on anyone foolish enough to disobey the law.

The bridge could only be traversed on foot and it took a full twelve minutes to cross it.

However, Leonardo had an urgent need to travel from Sinistra to Destra.

How could his ingenuity get him across the bridge?

Answer on page: 224

Golden Opportunity

"**D**o you comprehend probability, my friend?"

"Of course," responded Salaì. "I am no longer the innumerate child you took into your workshop. I know that if I toss a coin, the probability of it coming up heads are one in two and if I throw a die the chances of it being any particular number are one in six."

"Just so," said Leonardo with the cryptic smile that Salaì knew too well. "Observe. Here I have a bag containing four coins – one copper, one silver and two of gold.

"I draw two coins and reveal that one is gold. What is the probability that the other coin will also be gold?"

Answer on page: 225

Money Bags

"Observe, now I have two bags of coins." said Leonardo. Salaì chuckled. "Master, most people take their bags of coins to market or take up money-lending. You are the only man I know who uses them for mental exercise."

"Pay attention, young imp," said Leonardo although his pupil was no longer so young or particularly imp like. "Each bag contains three gold coins, three silver and three copper.

"Without looking into the first bag, I shall take from it as many coins as I can while leaving enough to ensure that one of each type remains. I put coins taken from the first bag into the second.

"Similarly, without looking, I transfer the smallest number of coins from the second bag to the first to ensure there will be two coins of each type in the first bag.

"Tell me, how many coins remain in the second bag."

Answer on page: 226

To Err is Human

It is believed that Leonardo built deliberate mistakes into his notes and diagrams so that his ideas could not be stolen.

Consider the number pattern below: what is wrong with it?

0 → 1 → 1 → 2 →

3 → 5 → 8 → 13 →

22 → 34 → 55 → 89 →

144

Answer on page: 226

Missing Pieces

The painting opposite is *Lady with an Ermine*. Six pieces of this work are missing. Can you match the numbered pieces below to the symbols on the painting?

I

II

III

IV

V

VI

Answer on page: 227

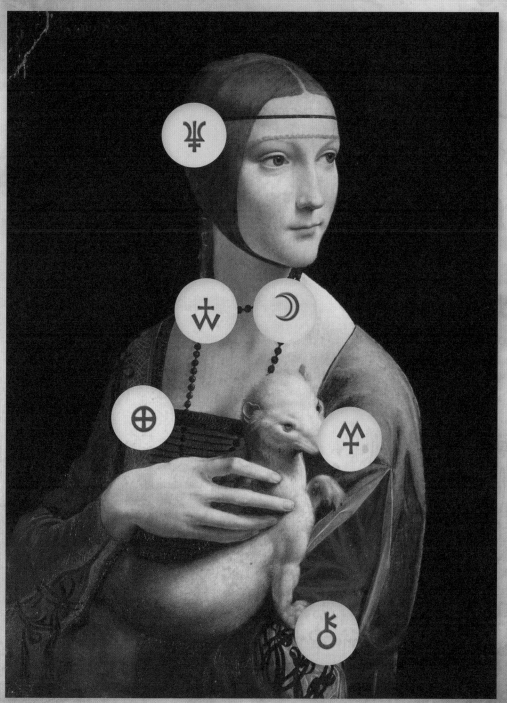

Countermeasures

Leonardo had devised a new contraption to protect his inner sanctum – a scale with three fulcrums.

When all the weights were applied, if the entire mechanism was in balance, the inner door would open; if not, potential intruders would find themselves trapped.

The weights were not marked, so Leonardo and his trusted companions had to remember the eight weights were as follows.

How are the weights applied to the scale so that everything balances?

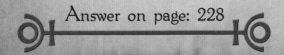

Answer on page: 228

Secret Accounts

The Medicis' accounts were encoded, but their cryptography was child's play to Leonardo.

Looking at the sum below, he concluded that the symbols represented the numbers 1 to 4.

With that in mind, can you give the value of each symbol?

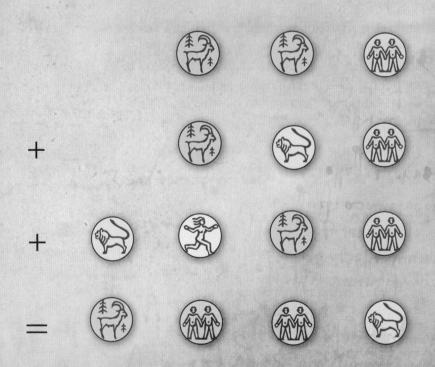

Answer on page: 228

Territories

The Duke was contemplating a map of his dominion. He called Leonardo to attend.

"This is a conundrum," said the Duke. "It is essential that no one faction builds up too much influence in one region or in neighbouring districts."

Can you insert the following six symbols so that only one is present in each coloured region and only one of each is present in each row and column?

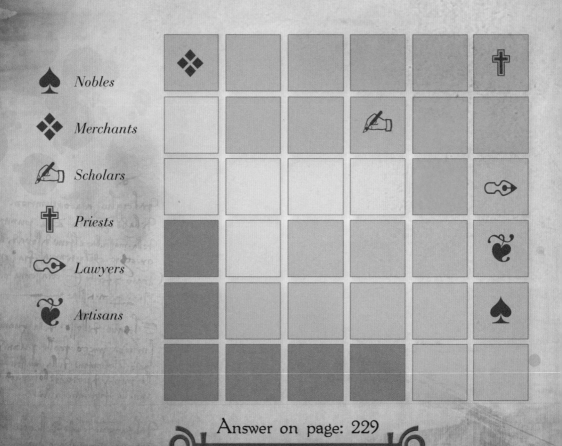

Answer on page: 229

Mountain

Write a number in each block, so that the value of each pair of blocks adds up to the block above it.

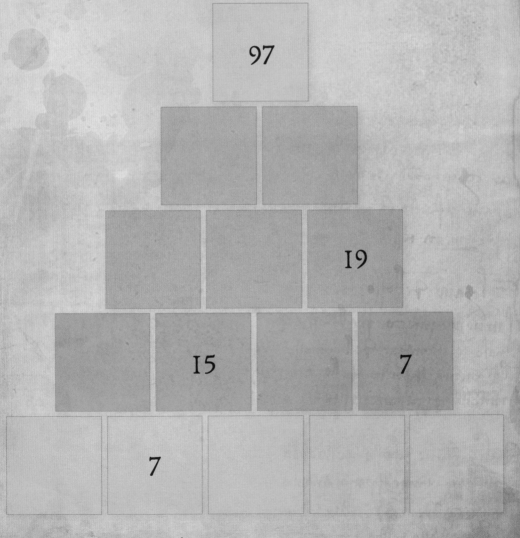

97

19

15 7

7

Answer on page: 230

"Blinding ignorance does mislead us. O, wretched mortals, open your eyes! "

Leonardo da Vinci

Master Puzzles

Although only a small number of his paintings survive, Leonardo's legacy exerts a fascination to this day.

He is remembered as a master painter, sculptor and inventor, but all his talents stem from an unquenchable curiosity and a love of puzzle solving.

An anecdote from Leonardo's childhood sums up this motivation: he recalled an excursion into the mountains where he discovered a dark cave. His imagination summoned up the most horrible monster lurking in the depths, but his curiosity to discover what was inside was stronger than his fear.

Manifold

Salaì was folding a piece of parchment, an invoice for a client.

"Tell me, Salai. If it were possible to fold that parchment 30 times, would it still fit in this room?"

Salaì blinked. The question sounded like nonsense.

Answer on page: 232

Paradox

"Imagine you are in a race against a tortoise," said Leonardo.

Salaì laughed, "Against a tortoise, Master?"

"Very well. Let us give the tortoise a head start of 1000 piedi to make things fair…

"We will assume that you can run 10 times faster than the tortoise. It is quite a nimble example of its kind.

"The race begins. When you have travelled 1000 piedi, the tortoise will be 100 piedi ahead of you. When you cover the next 100 piedi, the tortoise will be 10 piedi in the lead.

"So, young imp, will you ever catch up with the tortoise?"

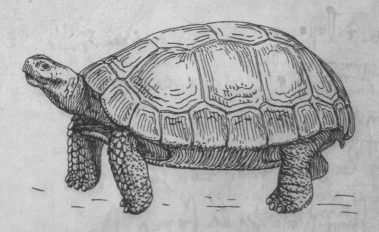

Answer on page: 232

A Code for da Vinci

L eonardo received a mysterious scroll, inscribed as follows:

Isaiah 24:16 Cobra is eager

A cryptic message – how could you
start to untangle its meaning?

Answer on page: 233

Leonardo-ku

an you insert these 9 astrological symbols into the grid below so that each line, each column and each 3x3 box contains one of each symbol?

⊙ ☽ ♈ ♄ ☿ ♓ ♃ ⚴ ♅

	⚴				♃	♄	♓	
			⚴				⊙	
	⊙			☽				♈
♄					⚴			
⊙	♈	☽				⚴	☿	♄
				☽				♈
☽				⚴			⊙	
	⚴			⊙				
♃	⊙	♈					♅	

Answer on page: 233

The Second Message

A second message arrived at Leonardo's workshop, as cryptic as the first.

Exodus 25:3 Oaf Clouds Visor

Answer on page: 234

Cash

Lorenzo Medici liked to reward his trusted lieutenants with coin. There were 9 lords whom he wished to recognize and 44 gold florins allocated from the treasury.

To encourage healthy competition, Medici wanted to give a different amount to each lord. Could this be done?

Answer on page: 234

Missing pieces

The painting opposite is *The Virgin and Child with St Anne and St John the Baptist*. Five pieces of this work are missing. Can you match the numbered pieces below to the symbols on the painting?

I

II

III

IV

V

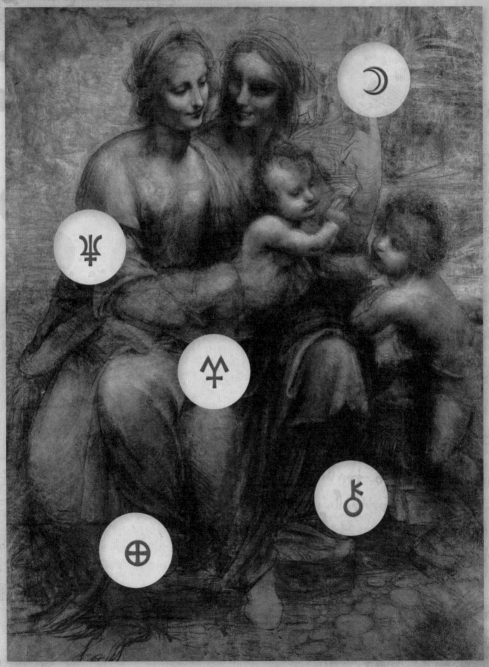

The Message Revealed

The third message caused Leonardo to smile.

"I think I may know who has been sending these encoded scripts," he said.

Proverbs 5:13
Chance Drove Rare Idol

Answer on page: 236

Polygon

L eonardo set an exercise for his new pupils:

"In the centre of your parchment, draw a circle with a radius of one inch. Then circumscribe the circle with an equilateral triangle. Next, circumscribe the triangle with another circle. Then circumscribe the second circle with a square. A third circle, then a regular pentagon. Continue this procedure, each time increasing the number of sides of the regular polygon by one.

"If you were to repeat this process, adding larger circles and polygons, approximately how big a sheet of parchment would you need?"

Answer on page: 236

Vitruvian Men

The images below form identical pairs – except one – which belongs to a triplet. Can you spot it?

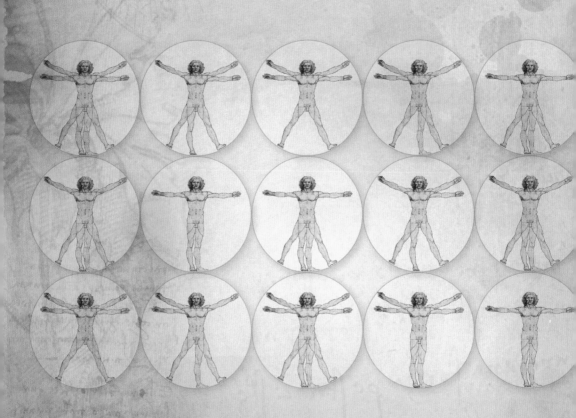

Answer on page: 237

Pentagons

W hat does each symbol signify?

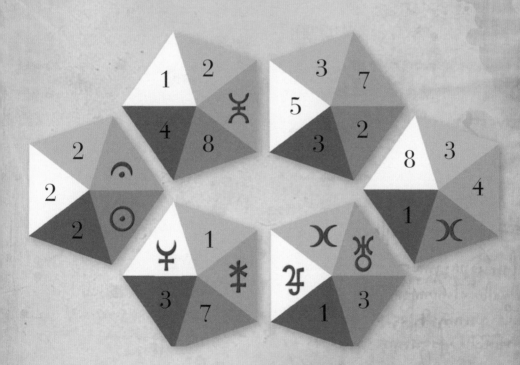

Answer on page: 238

A Realm Divided

Rodrigo Borgia divided up some land between his competitive children Giovanni, Cesare, Lucrezia and Gioffre.

Each child demands a region of the same size and shape as their siblings, and must contain a church, a keep, a mill and a town.

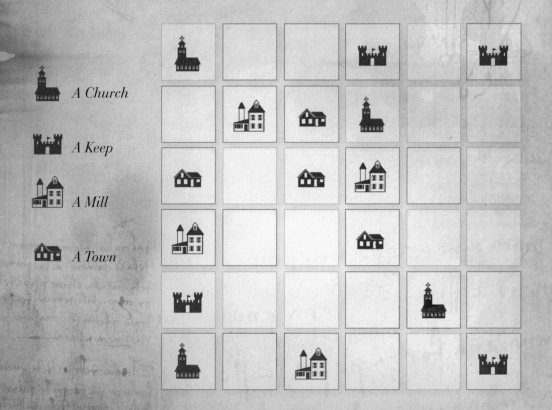

A Church

A Keep

A Mill

A Town

Answer on page: 239

Leonardo-ku

Can you insert these 9 astrological symbols into the grid below so that each line, each column and each 3x3 box contains one of each symbol?

⊙ ☽ ♓ ♄ ☿ ♓ ♑ ♃ ♅

Answer on page: 240

Another Realm Divided

Poor Rodrigo Borgia was being harangued by his four acquisitive children again. He had to give each of them a piece of land of equal size and shape, and to remain fair, each piece of land must contain iron, corn, livestock and vines.

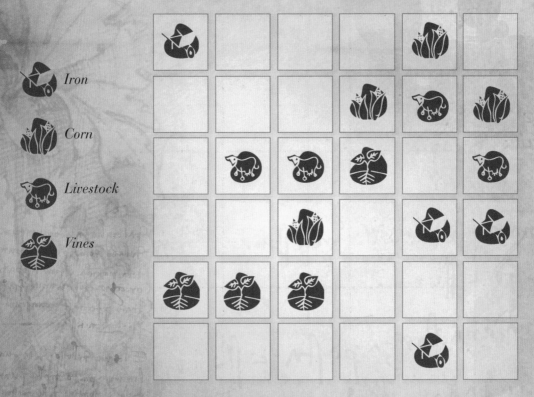

Lethal Logic

The Borgias used any means at their disposal to neutralize or eliminate their rivals. Using the grid and clues below can you ascertain who did what to who and why?

	Power	Money	Revenge	Cardinal	Ambassador	Lord	Blackmail	Murder	Seduction
Cesare									
Lucrezia									
Giovanni									
Blackmail									
Murder									
Seduction									
Cardinal									
Ambassador									
Lord									

Clues

Lucrezia Borgia seduced her victim, but it wasn't for revenge.

Giovanni was driven by an insatiable lust for power but he didn't kill to achieve it (this time) and his victim was not a Cardinal.

The French Ambassador had offended the Borgias and was targeted for revenge.

Answer on page: 242

Territories

"You did so well helping me to divide the realm among the various guilds and factions," said the Duke, "I need you to do the same with this recently conquered land."

Can you insert the following six symbols so that only one icon is present in each coloured region and only one of each is present in each row and column.

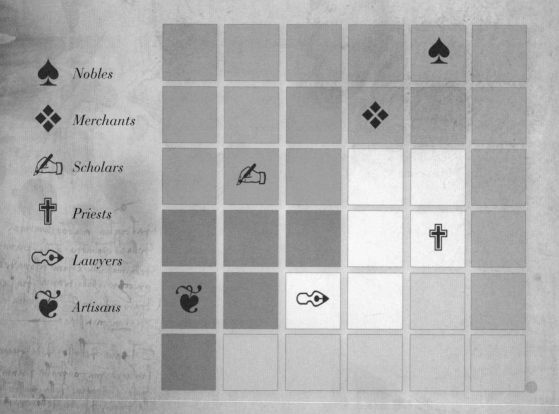

♠ *Nobles*

❖ *Merchants*

✍ *Scholars*

✝ *Priests*

⟜ *Lawyers*

❧ *Artisans*

Piece of Cake

"We have a custom here that when two people sit down to share a cake, one cuts and the other chooses his piece, thereby ensuring that the portions are equal." said Lorenzo de' Medici, Leonardo's current patron.

"However, this evening I am dining with three distinguished guests. Is there any way I can apply our custom to ensure that they all receive a fair share?"

Answer on page: 244

Missing pieces

The painting opposite is *Beatrice d'Este, Duchess of Bari*. Five pieces of this work are missing. Can you match the numbered pieces below to the symbols on the painting?

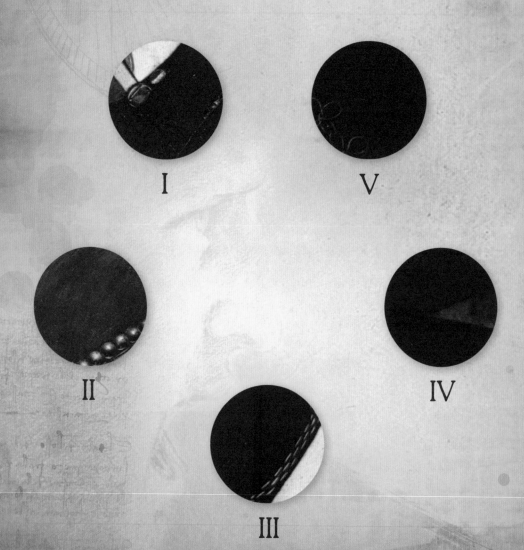

I

V

II

IV

III

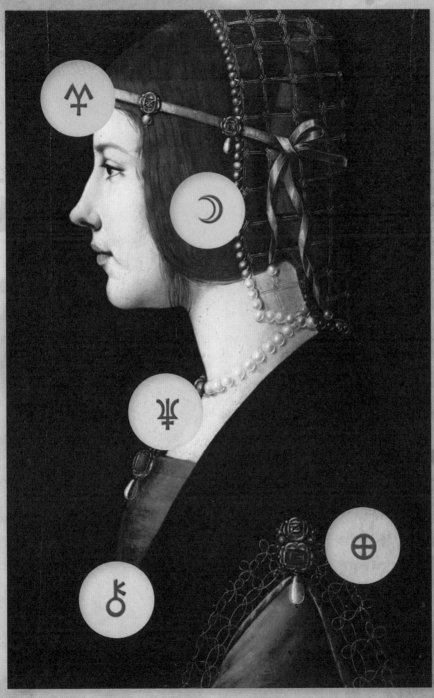

Answer on page: 244

Relations

"It is unnatural and ungodly!" shrieked the Cardinal.

"Calm yourself," said Pope Alexander, "and explain the situation."

"There is a rumour circulating that there are two priests in Florence who are unnaturally related."

The Pope pursed his lips, "How so?"

"Father Alberto is both uncle and nephew to Father Benedict. Conversely Benedict calls Alberto both 'uncle' and 'nephew'."

"Unnatural indeed," said the Pope. "Is it even possible?"

Answer on page: 245

Heavens Open

Five priests were on their way to church when they were caught in a sudden shower of rain. Four of them ran for cover but were still soaked. The fifth did not move yet he remained perfectly dry.

How can this be?

Answer on page: 245

Commissions

Leonardo had been bombarded with commissions. Salaì was charged with keeping track of them. Who is the client, what is the subject, what is the medium and how much are they offering?

	500 florins	750 florins	1000 florins	A horse	Himself	The Madonna	Oil Painting	Fresco	Sculpture
Sforza									
Borgia									
Medici									
Oil Painting									
Fresco									
Sculpture									
A horse									
Himself									
The Madonna									

Clues

The Madonna was to be depicted as a sculpture and was not commissioned by Borgia.

Sforza offered 500 florins, but it was not for a self-portrait.

The self-portrait was commissioned for less than what Medici offered, but more than the oil painting.

Answer on page: 246

Waypoint

A rider was making his way across Italy when he passed a stone yard marker that proclaimed:

Rome
97 Miles

The next marker said **89 miles**, the one after that **83**, then **79** then **73**.

When he gets to the 19-mile marker, how many more markers will he pass before he arrives in Rome?

Answer on page: 247

Number Magic

There are six sequential numbers that can be put into the squares of this grid so that the rows, columns and long diagonals add up to the same number.

		14
	11	
8		

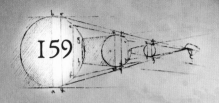

Leonardo-ku

Can you insert these 9 astrological symbols into the grid below so that each line, each column and each 3x3 box contains one of each symbol?

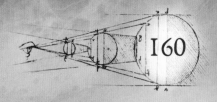
The Sum of Arts

Determine the value of each painting and work out which number should replace the question mark.

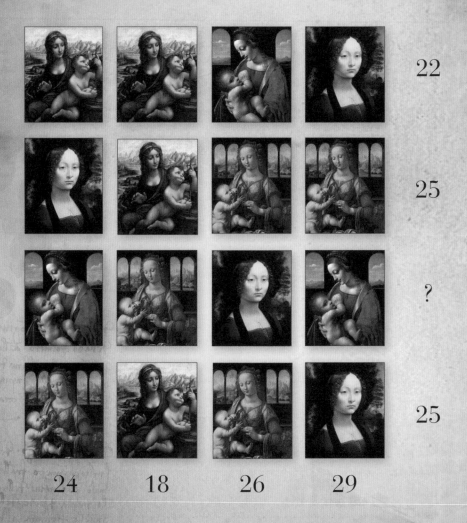

22

25

?

25

24 18 26 29

Answer on page: 249

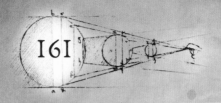

Logic Boxes

Work out the relationship between the numbers in each box to find the missing number.

13		6
	209	
8		3

7		9
	272	
5		12

11		3
	?	
2		14

Answer on page: 249

Value Judgement

The Renaissance gave us many artists whose names have become immortalized and their value to civilization is beyond reckoning.

However...

...Michelangelo is worth 25, Botticelli and Donatello are both worth 16. How much is da Vinci worth?

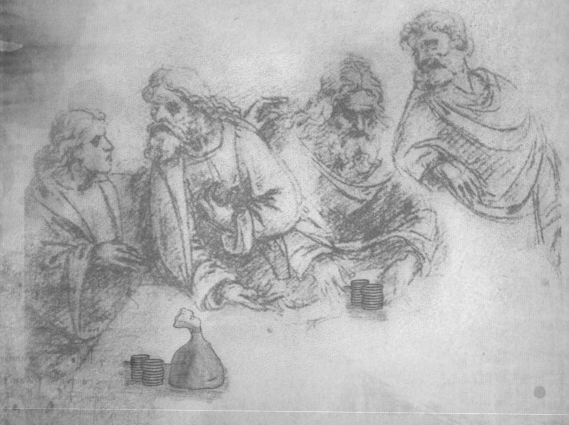

Answer on page: 250

Aftermath

After a skirmish with Papal troops, Medici's soldiers took stock of their injuries.

Of the 131 Medici soldiers, 112 were injured, while 46 also suffered amputated arms, 16 had amputated legs and 10 suffered incurable infections. The amputees and infected would never be fit to fight again, the rest would eventually be fit for duty.

What is the maximum number of casualties who will recover?

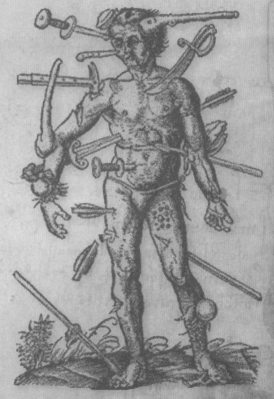

Answer on page: 250

Missing pieces

The painting opposite is *La belle ferronieré*. Five pieces of this work are missing. Can you match the numbered pieces below to the symbols on the painting?

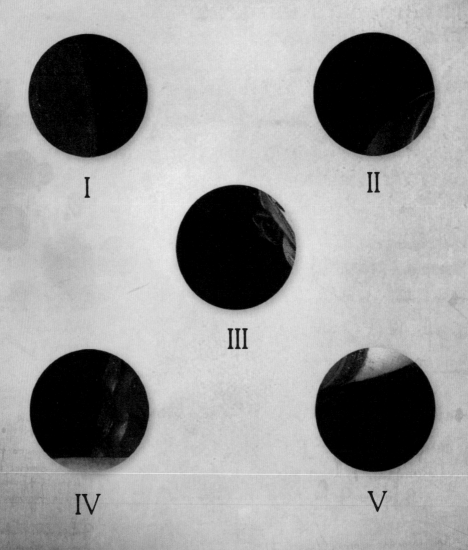

I

II

III

IV

V

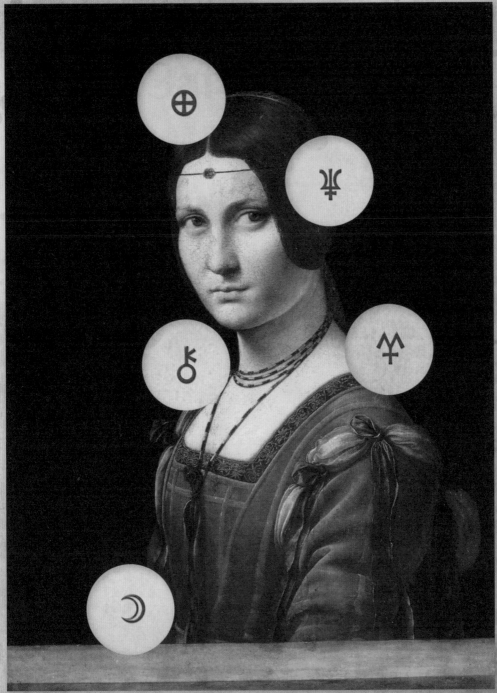

Answer on page: 251

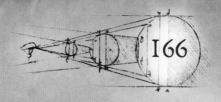

A Revolutionary Lock

A locking mechanism consists of four cogs of increasing size (8 teeth, 9 teeth, 10 teeth and 18 teeth).

All the arrows must point upwards for the lock to open. How many revolutions must the small cog turn through to make this happen?

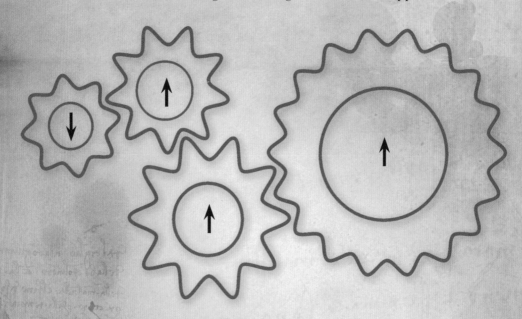

Answer on page: 252

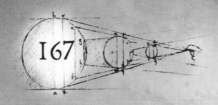

The Sum of Arts

Determine the value of each painting and work out which number should replace the question mark.

32

?

32

12

32 12 26 61

Answer on page: 252

Countermeasures

The Duke of Milan had heard of Leonardo's scales-based security system and demanded a similar mechanism for his treasury.

The weights were:

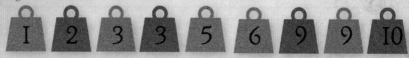

1 2 3 3 5 6 9 9 10

How are the weights applied to the scale so that everything balances?

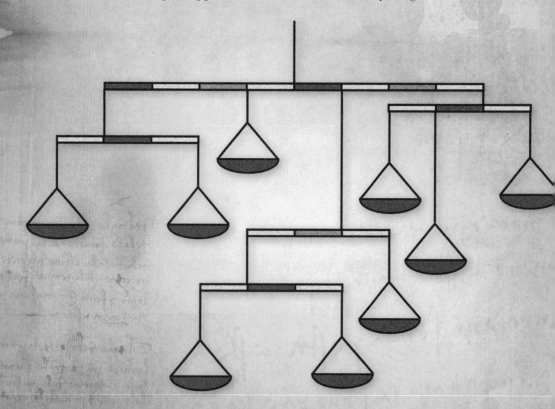

Answer on page: 253

Cognition

Leonardo's contraptions had become increasingly sophisticated. This intricate system of cogs adorned the wall of his workshop, daring the mechanically minded to turn the handle.

If the handle is turned anti-clockwise, will the load go up or down?

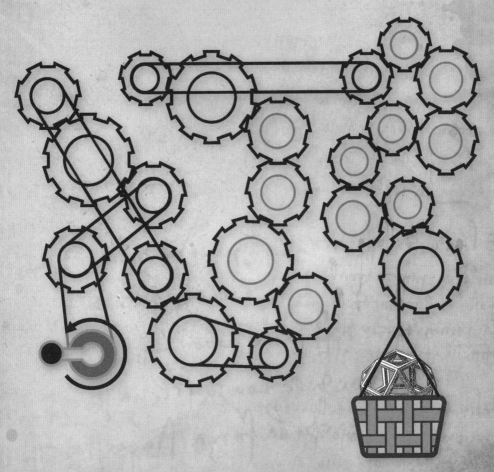

Answer on page: 253

fayre Play?

A fayre had come to Florence and many games of skill and chance had been set up to divest gullible Florentines of their money.

Leonardo spied an attractive young woman about to try her luck at the "Roll-a-Florin" stall. The object of the game was to roll a coin with a diameter of 1-inch on a varnished table so that it came to rest wholly within a 2x 2 inch square of the painted grid as shown below.

Leonardo pursed his lips and asked the stall holder, "What will the lady win if her coin misses the lines?"

"She will win one florin in addition to having her own florin return, milord," was the reply.

"My lady," said Leonardo, "I would recommend either another game or a better rate of exchange from this one." Why?

Smithy

Leonardo visited a local blacksmith and asked:

"How much does five cost?"

"That would be two lire, sir."

"How much for nine?"

"Three lire."

"Twelve?"

"Four lire."

What could Leonardo have been buying?

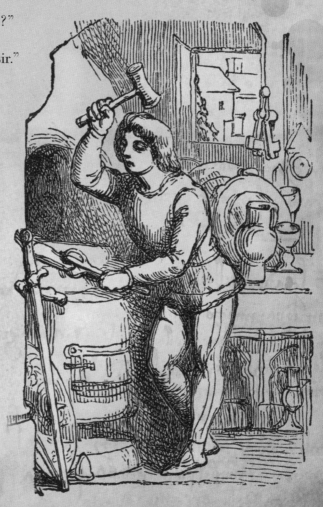

Answer on page: 255

Solutions

Novice Puzzles

The Sum of the Arts

? = 6

1 3 2 4

A Quarrel

Salaì hung his hat on the tip of the quarrel before firing the crossbow.

Cognition

He should turn the handle anticlockwise.

Pattern Recognition

♀

Each vertical line and horizontal column contains:
- A square, a circle and a triangle.
- A green shape, an orange shape and a yellow shape.
- A Sun ☉, a Venus ♀ and a Mars ♂ sign.

So the missing symbol must be a green circle containing a Venus sign.

16–17 **Missing Pieces**

I II III IV V

♆ ⊕ ♅ ☽ ☿

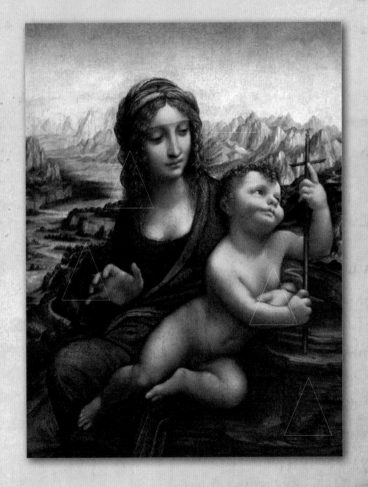

18 ## A Dark Dream

The guard was executed for dereliction of duty. Last night (while dreaming) he was supposed to be on watch.

19 ## The Merchant

Nine gemstones. He sold three in the morning and three in the afternoon.

20 ## The Turn of a Card

The phrasing of the question is important – it concerns gold cards. So the second card from the left can be ignored. By turning over the first card you can immediately conclude "no" if it shows a cup. If it shows a star, you need to turn over one other card, but which one? You might be tempted to turn the fourth card but this won't help you. You must turn over the third. If it is gold, the answer is "no"; if green, it does not matter what colour the fourth card is because you have determined that no gold card displays a cup and the answer is therefore "yes".

Windows of the Soul

21 eyes. The angel is believed to be Gabriel who, like all angels named in the Bible, was male.

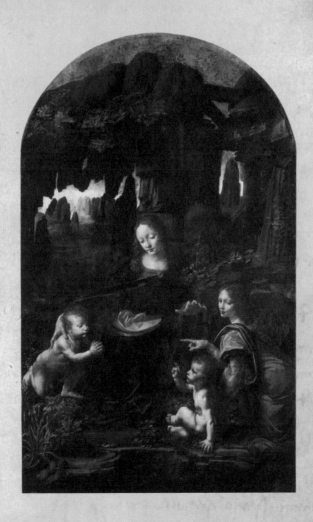

22-23 # Concentration

24 # Too Clever

To solve the puzzle you must clear your mind of complex calculations and just record what you see.

Starting with the second line, each line describes the one above it. The first line consists of a single number "1", so you can read it as "one of one" or 1…1.

The third line then contains "two of one" or 2…1.

The fourth line contains "one of two and one of one" or 1…2…1…1. And so on.

So the next line should describe "three of one, one of three, one of two, one of one, one of three, one of two and two of one":

3 1 1 3 1 2 1 1 1 3 1 2 2 1

25 **Leonardo-ku**

Page

Missing Pieces

I II III IV V

⛢ ☿ ♆ ☾ ⊕

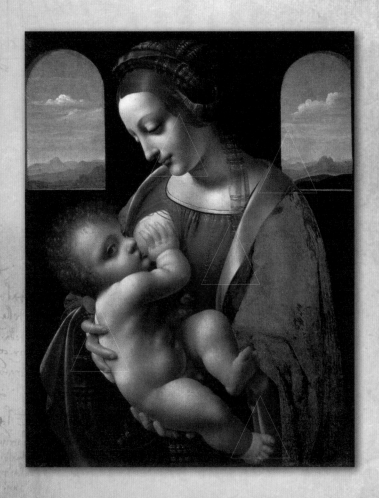

28 # Pattern Recognition

Each line and column contains:
- An orange square, a yellow square and a green square.
- Two horses pointing right and one pointing left
- Two large horses and a small horse.

So the missing square should be orange with a large horse facing right.

29 # The Art of Numeracy

Hopefully you took the hint that this is not a mathematical puzzle. Group I consists of figures that are made of curved lines, Group II of straight lined figures and Group III of figures made of straight and curved lines. So fifteen and sixteen belong in Group III and seventeen goes into Group II.

Group I	Group II	Group III
0 3 6	1 4 7	2 5 10
8 9	11 14	12 13

30 Against the Grain

The taxman would need to collect 33 and a third of a bag. Since 3 per cent of the grain is good, so 100 bags of mixed grain would yield enough for 3 bags of edible grain. Dividing 100 by 3 gives you 33⅓.

31 Leonardo-ku

32 A Multitude?

Three guests.

33 Just a Moment

The anti-clockwise moment acting on the left hand side is force (4) multiplied by the distance from the pivot (6) which makes 24. The right hand thread is 3 units from the pivot, so the object attached to it must have a force of 8 to balance the lever.

34 The Guilds

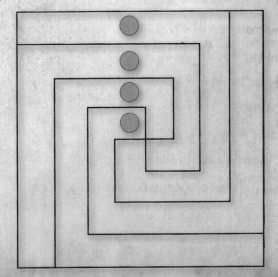

The Sum of the Arts

? = 11

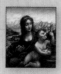 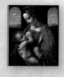 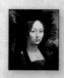 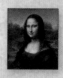

1 7 3 4

One Coin

Take the coin from bottom of the vertical line and place it on the intersection as shown.

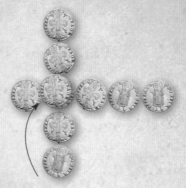

Rope

Salaì should tie one end of the rope to the trunk of the willow and then, holding onto the other end of the rope, walk right around the edge of the lake until he comes back to where he started. The doubled-up rope will be stretched between the oak and the willow, creating a convenient line for him to pull himself across the water.

38–39 Missing Pieces

I II III IV V

☿ ♆ ♅ ☾ ⊕

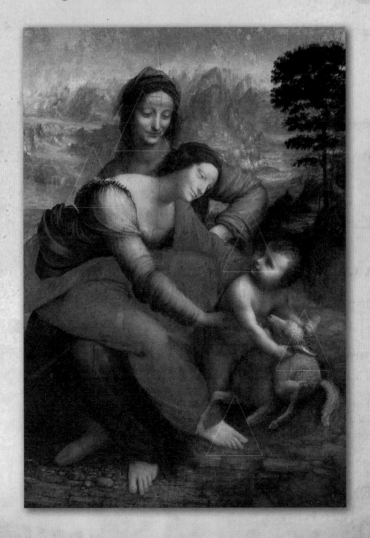

Page

40 Leonardo Ku

41 The Sands of Time

Start both glasses simultaneously. As soon as the 4-minute glass has run out, turn it over. When the 7-minute glass runs out, do the same. When the 4-minute glass expires for the second time you know that 8 minutes have elapsed and 1 minutes' worth of sand has fallen from the 7-minute glass.

So all you have to do is turn the 7-minute glass over until that minute runs back, which gives you 9 minutes.

42 Pattern Recognition

Each line and column contains:
- One man with 4 arms, one with 2 raised arms, one with 2 lowered arms.
- Two men in normal orientation, one upside-down.
- A yellow square and two green squares.

So the missing square should be green, containing an upright man with two raised arms.

2 4 6 8

47

Two Coins

Take the two coins shown from the left hand side
and reposition them on the right hand side, pushing
the rows of coin so that the whole thing becomes
square again.

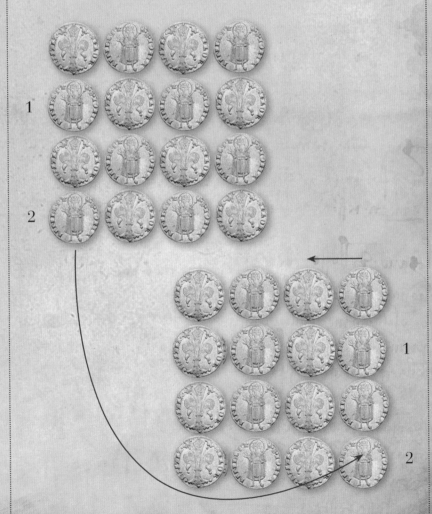

Page

48–49 Missing Pieces

I II III IV V

⚴ ☿ ☽ ♆ ⊕

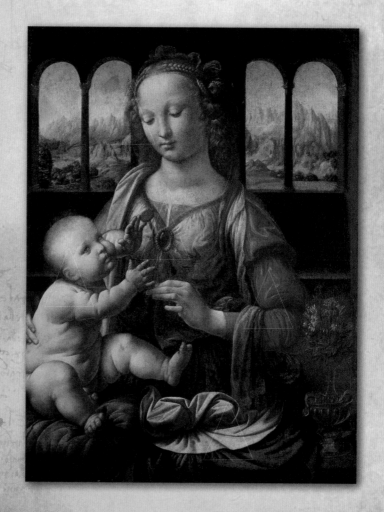

50

three fees

The Duke paid the architect 9 florins and the painter and sculptor 3 florins each.

51

Box Clever

Box III.

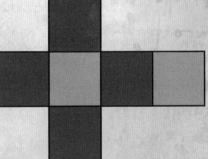

III

Page

54 Casualties

The first general went to war with twice as many men as the first.

55 Riders

Thirty eyes means there were fifteen creatures in total. The only way forty four legs can be divided among fifteen is 7 x 4 legs (horses) plus 8 x 2 legs (men). So seven of the men were riding and the eighth was on foot.

Page

56 Number Magic

Two solutions are possible.

IV	IX	II
III	V	VII
VIII	I	VI

IV	III	VIII
IX	V	I
II	VII	VI

57 Vulgar Factions

Rome has 7 supporters, the Medicis have 5.

Page

58-59 # Missing Pieces

I II III IV V

⊕ ♆ ☽ ⚥ ♇

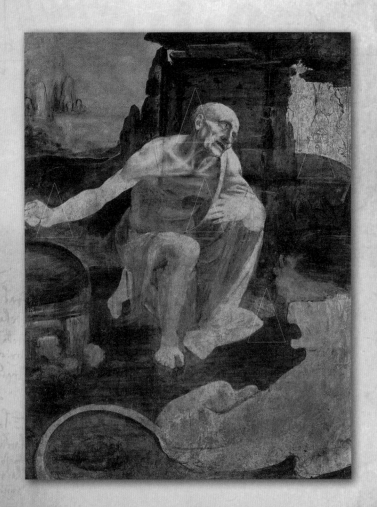

60 # A Sign

If the sign is re-erected with the correct arrow pointing to their point of departure, the arrow pointing towards Volterra will be correctly aligned.

61 # Leonardo Ku

65 # Vulgar Fractions

It's best to tackle this puzzle in true Leonardo style –
back to front. Nine-tenths of 100 is 90, eight-ninths
of 90 is 80, seven-eighths of 80 is 70, six-sevenths of
70 is 60, five-sixths of 60 is 50, four-fifths of 50 is 40,
three-quarters of 40 is 30, two-thirds of 30 is 20 and
half of 20 is 10, your answer.

66 # Attraction

Salaì can select either bar and push it against the
middle of the other bar to form a T-shape. If the
selected bar is magnetized, it will pull the other.

67 # Numerals

There are, in fact, two possible solutions. Both require
you to move the crossbar from the addition sign.

VI - II = IV

Or

VII - II = V

Missing pieces

I	II	III	IV	V
⊕	♀	☽	♆	☿

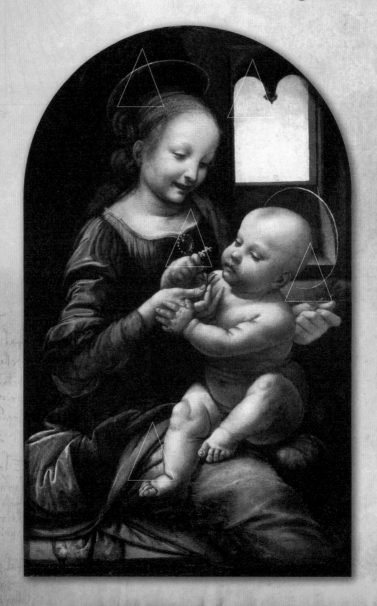

70

In Vino Veritas

To find the answer, Salaì would simply have to tilt the
barrel to the point just before the wine spilled out.
If the bottom of the barrel is just covered by liquid,
then the barrel is exactly half full. If the bottom is
completely covered, the barrel is over half full. If any
of the bottom is visible, it is more than half empty.

71

Cannon

The rate of fire might seem to be the same, but the
reloading intervals are different. The first cannon
has 4 intervals between the first shot and the last,
each of 1¼ minutes; the second has 9 intervals of $1\frac{1}{9}$
minutes each, which means it could fire 12 times in
$12\frac{2}{9}$ minutes rather than 13¾ minutes.

72

Wheels in Motion

If the device were suspended in space, one revolution
will move the tile 1 braccio forward. On the ground
a revolution will move the entire device 1 braccio.
So the tile will be moved a total of 2 braccia.

Page

73 Leonardo-Ku

74 Accuracy

The first cannon hit 28 out of 84 times, the second 25 out of 75 times. So they both have the same ratio of 1:3.

Page

75 Recruitment

Two of the men were adept in all three skills, while the third couldn't do any.

76 Defection

500 soldiers.

77 Deadline

Cesare was clearly jesting. If the dogs had not eaten in five months, they would be dead.

Missing Pieces

I II III IV V

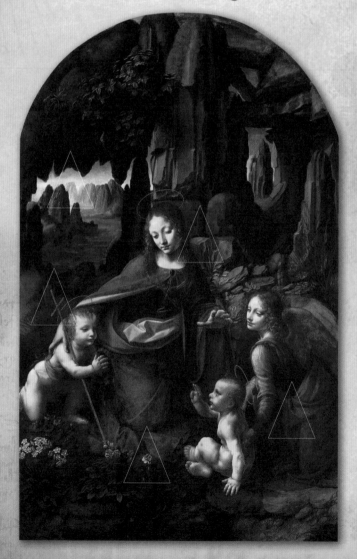

Page

80 Generosity

A secret.

81 Papal Bull

Rodrigo Borgia and Pope Alexander VI was one and
the same person.

82 Horse Race

He came in last. By overtaking the rider in second
place, he put himself in second place. The two who
overtook him put him in fourth place.

83 Leonardo Ku

The First Shall Come Last

They mounted each other's horses, thereby ensuring that the winning rider's *horse* would come last.

Drop by Drop

Just one drop. After which, the goblet will no longer be empty.

The Power of Three

35 unique triangles can be seen within the shape.

A	B	C	D	E	F	G	H	I	J

A B C	A C D	A F J	B C J	B I J	C I J
A B D	A C E	A G I	B D F	C D I	F H I
A B E	A C G	A I J	B D I	C E G	F I J
A B F	A C I	A I J	B E J	C E J	G H J
A B I	A C J	B C H	B F I	C G J	G I J
A B J	A D E	B C I	B H I	C H J	H I J

87 # The Sum of Arts

? = 16

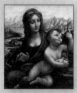 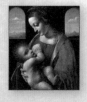 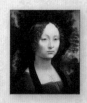 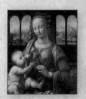

2 3 4 5

88–89 # Missing Pieces

I II III IV V

⊕ ♅ ☿ ☾ ♆

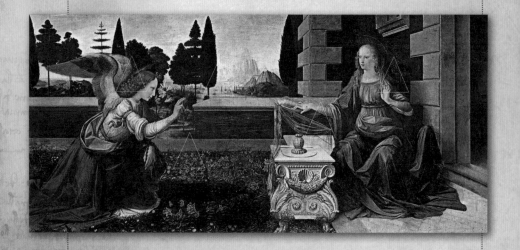

90

Cognition

He should turn it anti-clockwise.

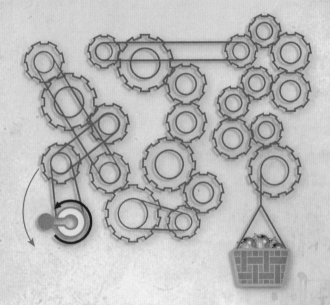

91

Pattern Recognition

Each line and column contains:
- A bald man, a curly haired man and a man with a hat.
- A yellow square, a red square and a green square.
- 2 faces looking right, 1 looking left.
- A square with a moon, one with a sun and one with no symbol.

Expert Puzzles

Witchcraft

He had packed the bell with snow so that it would not
ring and then sabotaged the ladder to buy time. When
the villagers reached the bell, the morning sun had
melted the snow, leaving no evidence.

Mistrust

Crossing	On the Island	In the Boat		On the Shore
1. Island to shore	1 Borgia /3 Medici	2 Borgia	⟫→	
2. Shore to island	1 Borgia /3 Medici	1 Borgia	←⟪	1 Borgia
3. Island to shore	3 Medici	2 Borgia	⟫→	1 Borgia
4. Shore to island	3 Medici	1 Borgia	←⟪	2 Borgia
5. Island to shore	1 Borgia /1 Medici	2 Medici	⟫→	2 Borgia
6. Shore to island	1 Borgia /1 Medici	1 Borgia /1 Medici ←⟪		1 Borgia /1 Medici
7. Island to shore	2 Borgia	2 Medici	⟫→	1 Borgia /1 Medici
8. Shore to island	2 Borgia	1 Borgia	←⟪	3 Medici
9. Island to shore	1 Borgia	2 Borgia	⟫→	3 Medici
10. Shore to island	1 Borgia	1 Borgia	←⟪	3 Medici /1 Borgia
11. Isalnd to shore		2 Borgia	⟫→	3 Medici /1 Borgia

The Truth Will Set You Free?

Leonardo could ask either guard, "Which door will the
other guard tell me is the way out?" He should then
ask to be let out of the other door.

Leonardo-Ku

[A 9×9 grid puzzle filled with astronomical/alchemical symbols]

Hats

Alberto got the apprenticeship. Caspar could see
Alberto and Benito. If their hats were the same colour,
he would know that his hat was the opposite colour
and would have answered immediately. As Caspar
remained silent, Alberto was able to deduce that
Caspar could see one hat of each colour and could
therefore say with confidence that his own hat was the
opposite of that worn by Benito.

More Hats

There are seven possible combinations. In the first two scenarios two of the boys are wearing white hats, so the third immediately knows his is black. In the fourth, by stating that he doesn't know, Estefan reveals that he sees either a black and a white hat or two black hats; so Fernando, seeing Estefan's hat is black and Gabriel's is white, knows that his must be black. In the remaining scenarios, if both Estefan and Fernando admit that they do not know their colour, Gabriel's hat is always black.

Estefan	Fernando	Gabriel	Outcome
Black	White	White	Estefan says, "Black."
White	Black	White	Fernando says, "Black."
White	White	Black	Estefan and Fernando both say, "No idea."
Black	Black	White	Estefan says, "No idea." Fernando says, "Black."
Black	White	Black	Estefan and Fernando both say, "No idea."
White	Black	Black	Estefan and Fernando both say, "No idea."
Black	Black	Black	Estefan and Fernando both say, "No idea."

Page

101

Lead into Gold

Leonardo divided the 9 coins into 3 piles: A, B and C.
He put pile A and pile B in either weighing pan of the
scales and left pile C to one side. If pile A or pile B was
heavier, it would become the "suspect" pile (the pile
containing the fake coin). If the scales balanced, pile
would be the "suspect" pile. Once he had established
which pile was 'suspect", Leonardo put the other two
piles aside. He then took 2 coins from the suspect pile
and put them on either side of the scales and kept
one in his hand. If one side of the scales was heavier,
it contained the fake coin. If the scales balanced, the
fake coin was in Leonardo's hand.

102-
103

Missing Pieces

I II III IV V

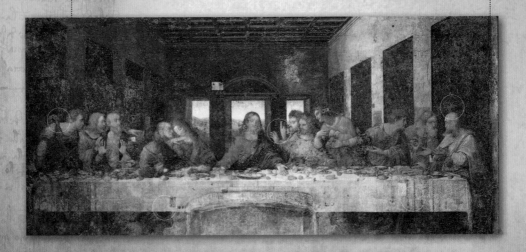

104

Something from Nothing

Like so...

105

The Last Straw

Cesare should take 2 straws, so 9 remain.

If Giovanni then takes 3, Cesare takes 1; if 2, then 2; if 1, then 3 – so that 5 remain.

Giovanni cannot win. If he takes 3, Cesare takes 1; if 2, then 2; if 1, then 3 – in all cases 1 straw remains, which he must take on his next turn.

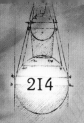

Page

106

Checkers

Four moves and two fingers. Move 2 checkers at a time, like so:

Page

107 **Leonardo-ku**

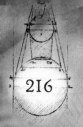

108

flagons

Leonardo picked up flagon II and poured its contents into flagon V.

I II III IV V VI

109

The Herald

The two armies must both travel 60 furlongs in order to meet. At a speed of 10 furlongs per hour, this will take 6 hours. Multiplying the heralds speed by 6 gives a total distance travelled of 480 furlongs.

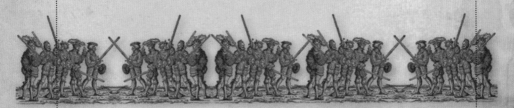

110

Battles

Number of soldiers at the start of a battle (x).

Number of soldiers at the end of a battle (y).

The casualty count can be expressed as:

$$x - y = x/2 + 10 \text{ or } x = 2(y + 10)$$

Working backwards from the final battle (in which he lost all of his remaining soldiers) y=0, so 2(y +10) gives 20 men at the start of the battle. So we know that y in the fourth battle is 20.

Battle 4 2(20 +10) = 60 men

Battle 3 2(60 +10) = 140 men

Battle 2 2(140 +10) = 300 men

Battle 1 2(300 +10) = 620 men (the size of the Lord's army at the start of the campaign).

111

Land Grab

The Pope divides the region, like so

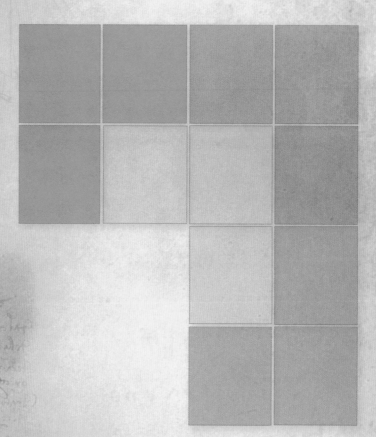

The Treasure Trove

The two portraits are of Leonardo himself and Lisa del Giocondo. The labels lack the letter E, so that rules out "Leonardo". However, remember that Leonardo liked to write backwards.

By pulling the levers A, S, I and L all 16 tiles will show the "Mona Lisa".

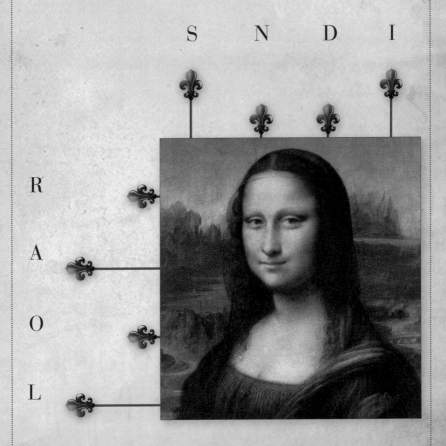

114

Heresy

"Not that which goeth into the mouth defileth a man; but that which cometh out of the mouth, this defileth a man."

With that, he took a grape from the bag and put it into his mouth before its colour could be seen.

He swallowed, then said, "I'm sorry, all this scripture made me rather peckish. But don't worry, you can confirm the colour of the grape I just ate by checking the one left in the sack."

115

Spies

The first spy cannot be telling the truth because the third spy's statement would also have to be true.

The third spy cannot be telling the truth because his statement would be corroborated by the other two spies.

The second spy's statement can be true, but only if the third is lying. Therefore, there are no French sympathizers in the region!

Page

116–
117

Missing pieces

I	II	III	IV	V	VI
⊕	☽	♅	♆	♂	♆

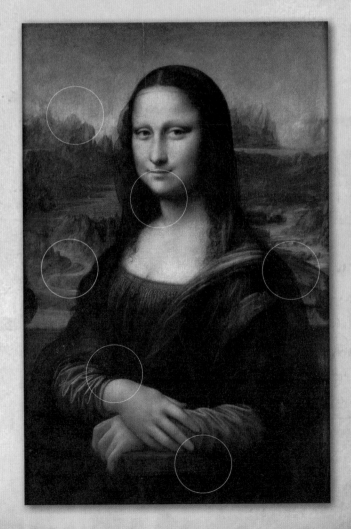

118

Self—fulfilling Prophecy

The number 1 occurs 3 times.
The number 2 occurs 2 times.
The number 3 occurs 3 times.
The number 4 occurs 1 times.
The number 5 occurs 1 times.

119

1000 Days of Sin

We must include the preacher himself
in the number of heretics, so the
question becomes: what is the sum
of all the numbers from 1 to 1000?

This is easier to solve than it first
appears: Add the first and last
numbers together:

$$1000 + 1 = 1001$$

The next two added together are:

$$999 + 2 = 1001$$

This applies to all 500 pairings.

So you simply have to multiply 500
by 999 and you get the answer...
(but don't forget the priest).

499, 501 heretics.

120 *Leonardo-ku*

121 Money-go-round

The coin will have made two revolutions.

x2

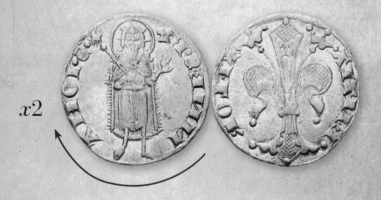

122 Guardroom

Leonardo started walking across the bridge as soon as the guard disappeared into the tower.

When he reached the middle of the bridge, he turned on his heel and headed back towards Sinistra, just as the guard was re-emerging from the tower.

"Oi, where do you think you're going? Come back here!" called the guard, brandishing his crossbow menacingly. "Get back to Destra this instant!" Leonardo complied, trying hard not to smile.

123 # Golden Opportunity

It is tempting to say, "1 in 3", which would be perfectly correct if the second coin were drawn from the sack after the first had been revealed. However, by drawing two coins, the combinations must be considered:

Gold (1)	Gold (2)
Gold (1)	Silver
Gold (2)	Silver
Gold (1)	Copper
Gold (2)	Copper
Copper	Silver

The Copper–Silver combination is clearly not possible, but there remain five other combinations, so the probability is in fact 1 in 5.

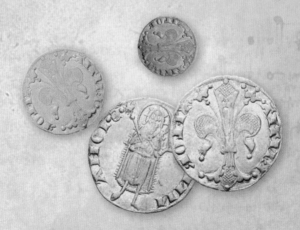

Page

124

Money Bags

Only 2 coins can be taken from the first bag, leaving two possibilities:

1. The first bag contains 3 of coin A, 3 of coin B and 1 of coin C; the second bag contains 3 of coin A, 3 coin B and 5 of coin C.

2. The first bag contains 3 of coin A, 2 of coin B and 2 of coin C; the second bag contains 3 of coin A, 4 of coin B and 4 of coin C.

Seven coins must be transferred back to ensure that there are at least 2 of each type in the first bag. This follows from Possibility 1 if the coins transferred back are 3 of coin A, 3 of coin B and 1 of coin 1.

So 4 coins will remain in the second bag.

To Err is Human

125

This should be a Fibonacci sequence – each subsequent number being the sum of the previous two.

The number 22 should be 21

$$0 \to 1 \to 1 \to 2 \to$$
$$3 \to 5 \to 8 \to 13 \to$$
$$21 \to 34 \to 55 \to 89 \to$$
$$144$$

126–
127

Missing Pieces

I II III IV V VI

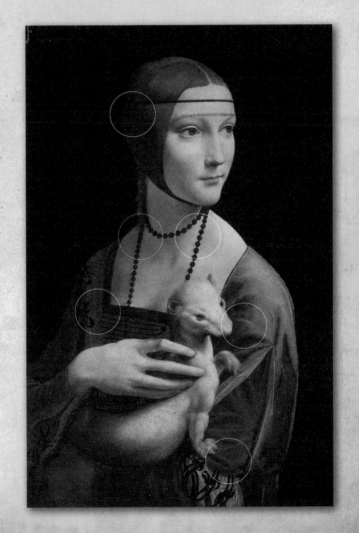

Page

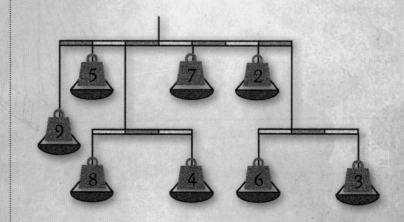

4 1 3 2

Page

130

Territories

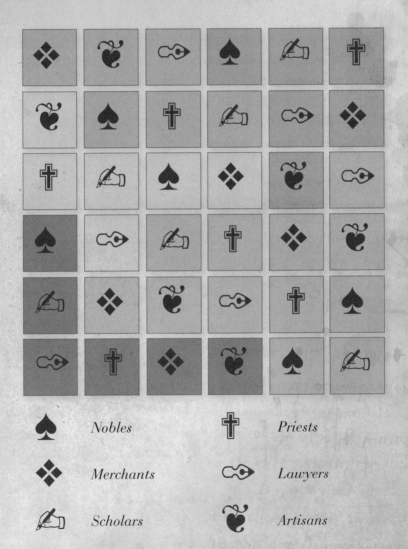

♠ *Nobles* ✝ *Priests*

◆ *Merchants* ᑫ *Lawyers*

✍ *Scholars* ᘓ *Artisans*

Page

131 **Mountain**

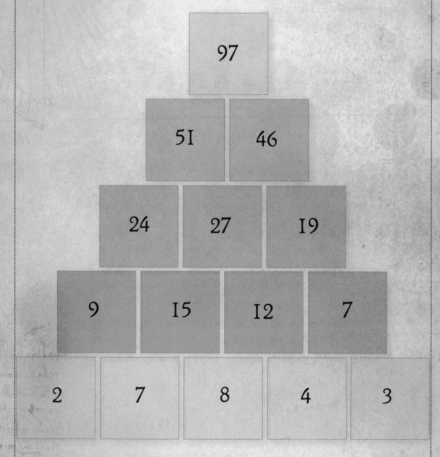

		97		
	51		46	
	24	27	19	
9	15	12	7	
2	7	8	4	3

Master Puzzles

Manifold

134

Let's assume that the parchment was .25 mm (0.01 inches) thick

Folds	Layers		Thickness
1	2	.5 mm	(.02 inches)
2	4	1 mm	(.04 inches)
3	8	2 mm	(.08 inches)
4	16	4 mm	(.16 inches)
5	32	8 mm	(.32 inches)
10	1,024	25.6 cm	(10.08 inches)
20	1,048,576	262.14 m	(860 feet)
30	1,073,741,824	268.44 km	(166.8 miles)

Not only would the pile not fit into the room, if placed lengthways it would easily stretch from Naples to Rome!

Paradox

135

This paradox was created around 2000 years before Da Vinci's time by the Greek philosopher Zeno of Elea. It appears that the runner (who was Achilles in Zeno's narrative) will never catch up with the tortoise because we will be dividing the distance between his current position and tortoise's by 10 indefinitely. In fact, Achilles will reach the tortoise at the 1,111⅑ piedi mark.

A Code for da Vinci

136

...woe unto me! The treacherous dealers have dealt treacherously; yea, the treacherous dealers have dealt very treacherously.

It seems to be a warning about betrayal, but who does it concern?

Cobra is eager is an anagram of Cesare Borgia, the ruthless son of Pope Alexander VI.

Leonardo-ku

137

138 The Second Message

And this is the offering which ye shall take of them; gold, and silver, and brass...

This message sounds less threatening. Perhaps it is a commission?

The anagram is Ludovico Sforza, the Duke of Milan who was Leonardo's patron for a time.

Exodus 25:3 Oaf Clouds Visor

139 Cash

The lowest number of coins can be distributed as:

$1 + 2 + 3 + 4 + 5 + 6 + 7 + 8 + 9$.

This makes 45, so the answer is: no.

Page

140–
141

Missing Pieces

I II III IV V

♅ ♆ ☽ ⚷ ⊕

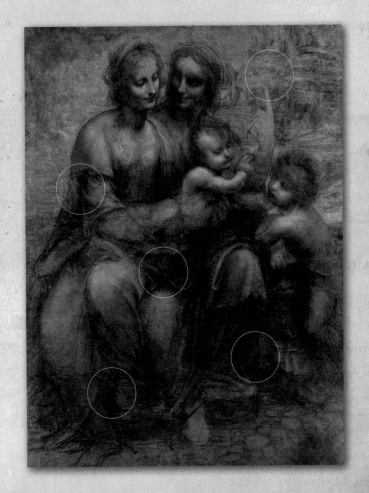

Page

142 The Messenger Revealed

And have not obeyed the voice of my teachers, nor inclined mine ear to them that instructed me!

This humorous admonishment could only come from one person, as the anagram reveals Del Verrocchio, Leonardo's old teacher.

Proverbs 5:13
Chance Drove Rare Idol

143 Polygons

Although the circle radii increase very quickly, they approach their limit at approximately 8.7 times the original radius of the circle. So a piece of parchment 18 inches square should be sufficient.

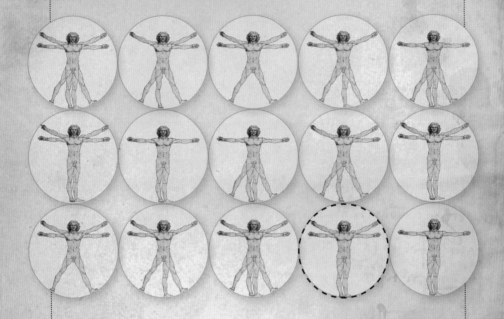

Page

145 Pentagons

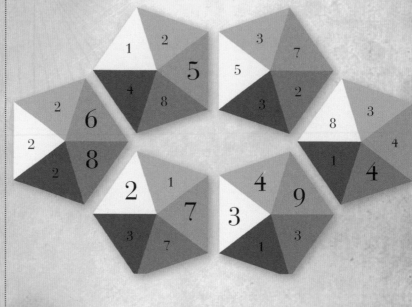

8	6	5	9	4	3	7	2
☉	☾	♅	♅	☿	♃	⚹	♅

Each pentagon contains numbers adding up to 20, and
the sides nearest adjoining pentagons adding up to 10.

146

Territories

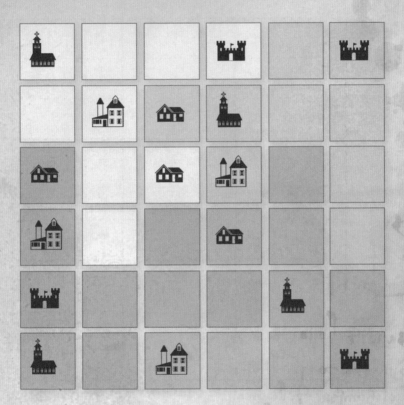

 A Church A Mill

 A Keep A Town

Page

147 Leonardo-ku

148 Another Realm Divided

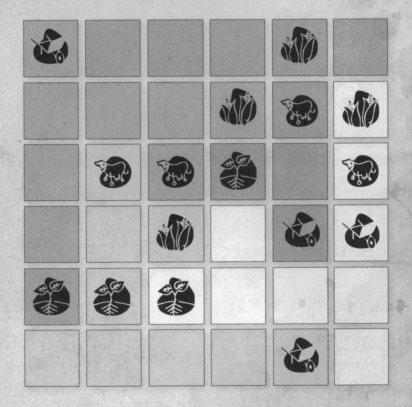

 Iron Livestock

 Corn Vines

Page

149

Lethal Logic

	Power	Money	Revenge	Cardinal	Ambassador	Lord	Blackmail	Murder	Seduction
Cesare			X		X			X	
Lucrezia		X		X					X
Giovanni	X					X	X		
Blackmail	X					X			
Murder			X		X				
Seduction		X		X					
Cardinal		X							
Ambassador			X						
Lord	X								

It was revenge that motivated Cesare to Murder the Ambassador.

Lucrezia's goal was money when she seduced the Cardinal.

Giovanni gained power by blackmailing the Lord.

Page

150 # Territories

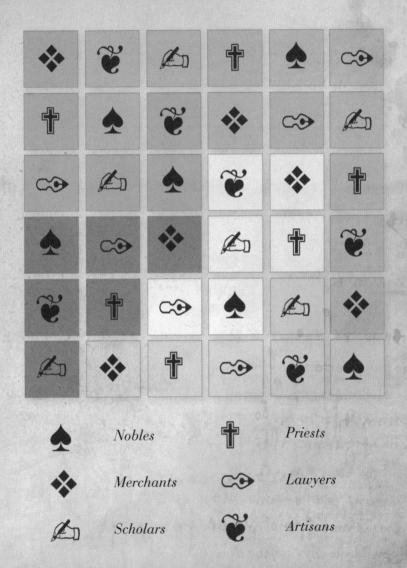

♠ *Nobles* ✝ *Priests*

◆ *Merchants* ✎ *Lawyers*

✍ *Scholars* ✿ *Artisans*

Page

151 Piece of Cake

The first guest cuts off what he considers to be a fair quarter of the cake. The next guest may either reduce the amount if he thinks it is more than a quarter share or pass it to the next guest, who has the same option. The last person to cut the slice keeps it or else, if it remains unaltered, it is returned to the first guest and the second guest takes his turn in cutting a third from the remainder of the cake.

152– 153 Missing Pieces

I	II	III	IV	V
♅	☽	♆	♁	⊕

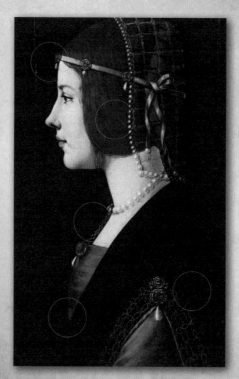

Page

154

155

Relations

Suppose two men married the mother of the other after their respective fathers has passed away. Each fathered a son with their new wives: Alberto and Benedict. The sons were half-brother to the other's father and both uncle and nephew to one another.

Heavens Open

It was the funeral of the fifth priest; the other four were carrying his coffin.

156 # Commissions

	500 florins	750 florins	1000 florins	A horse	Himself	The Madonna	Oil Painting	Fresco	Sculpture
Sforza	X			X			X		
Borgia		X			X			X	
Medici			X			X			X
Oil Painting	X			X					
Fresco		X			X				
Sculpture			X			X			
A horse	X								
Himself		X							
The Madonna			X						

Sforza commissioned a 500 florin oil painting of a horse.

Borgia paid 750 florins to have himself depicted in a fresco.

Medici commissioned a sculpture of The Madonna.

157 **Waypoint**

7 markers. The markers display consecutive prime numbers.

17 Miles 13 Miles 11 Miles 7 Miles 5 Miles 3 Miles 2 Miles

158 **Number Magic**

10	9	14
15	11	7
8	13	12

Page

159 Leonardo-ku

160

The Sum of Arts

? = 25

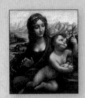 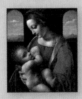 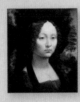 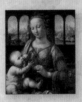

4 5 6 9

161

Logic Boxes

Add the top two numbers together, then the bottom two. Multiply the two sums to obtain the centre number.

The answer is 224.

13	6	7	9	11	3
209		272		224	
8	3	5	12	2	14

162

Value Judgement

He is worth 9.
Each artist's value
is the number of
vowels in their
name squared.

163

Aftermath

85. If you assume that the 46
people who lost an arm, also
lost a leg and contracted an
infection, you can subtract
46 from the total soldiers
(131), which gives 85.
Since this number is lower
than the total casualties
(112), it is the maximum
number who will recover.

Page

164 –
165

Missing Pieces

I II III IV V

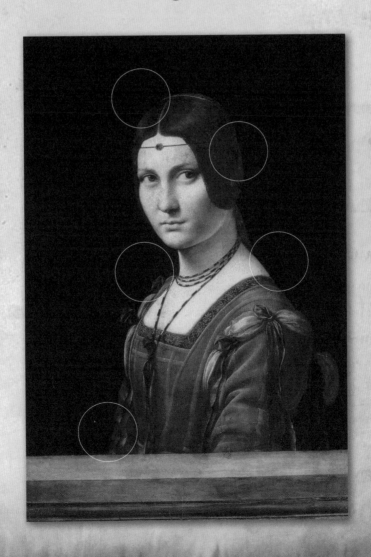

166

A Revolutionary Lock

22.5 revolutions of the 8-cog translates to 20 revolutions of the 9-cog, 18 revolutions of the 10-cog and 10 revolutions of the 18-cog.

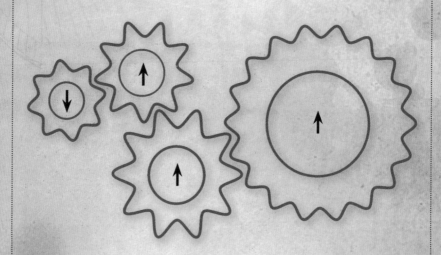

167

The Sum of Arts

? = 45

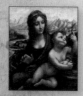
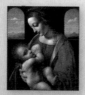
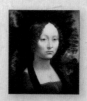
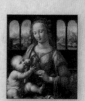

5 4 19 2

168 # Countermeasures

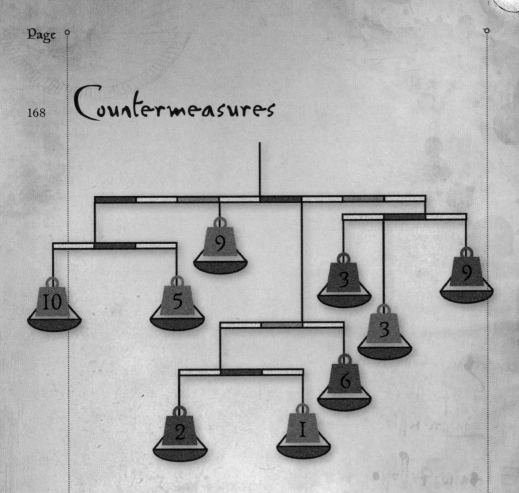

169 # Cognition

It will go up.

170

Fayre Play?

To win, the lady's florin must fall within the shaded area of a 2 x 2 inch square.

The winning area is 1 square inch, so the remaining losing area of any square is therefore 3 square inches, giving odds of 3 to 1 in favour of the stall holder. A fairer payout would be 3 florins plus the original stake. The profit for the stallholder then lies in the width of the gaps between the squares.

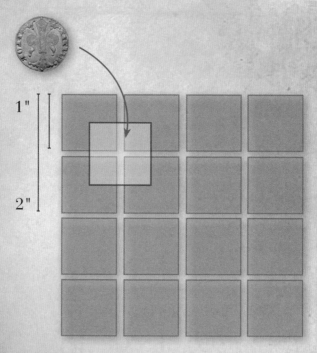

171

Smithy

He was buying wrought metal roman numerals for a clock. It cost one lire for each line.

V is 2 lire. IX is 3 lire and XII is 4 lire.

·ᘒ Acknowledgements ᘒ·

Illustrations courtesy of:

Carlton Books Ltd

Dover Books

Istockphoto

Thinkstock.com

karenwhimsy.com

Wikimedia Commons.